THE ARTIST'S GUIDE
TO SELECTING
COLOURS

by
MICHAEL WILCOX

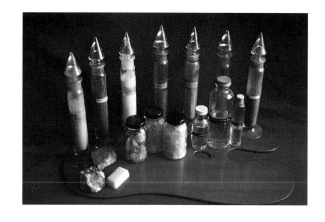

SCHOOL OF COLOUR
PUBLISHING

To
Joy Turner Luke and Mark Gottsegen
for their work on behalf of the artist

Acknowledgements

A book such as this would not be possible without the expertise and hard work of a team of dedicated and skilled people.

I would particularly like to thank Anne Gardner and Margaret Woodward for their tireless efforts in providing full support during the research and writing stages.

Joy Turner Luke, past Chairperson of the ASTM Sub Committee on artists' paints deserves a special mention. Without her selfless help and unquestionable expertise offered over past years, I would still be working in semi darkness.

Text, Illustrations and Arrangement,
Copyright © The Wilcox Trust. 1997
ISBN 09587 891 8 5

Editor
Margaret Woodward

Technical support
Anne Gardner

Additional research
Leon Wilcox
Elizabeth Moran
Dave Wallis

Design, text and illustrations
Michael Wilcox

Published by
Colour School Publishing
P.O. Box 516 Wanneroo
Perth 6065
Western Australia

Printed by
Tat Wei Printing &
Packages Pte., Ltd.
Singapore

Colour separations by
Colour Symphony Pte Ltd.
Singapore

Introduction

Like countless other painters, I have spent many hours in art shops pondering over which colours to purchase. Which would fade, which were of real use and which would help me to improve my work?

The sheer number of colours available, together with what was often conflicting advice, made the whole exercise bewildering. I never once purchased with absolute confidence and my research since has shown that very few artists ever do.

This book is about artists' paints; watercolours, oils, acrylics, gouache and alkyds. It is intended as a guide towards the selection of a suitable palette, in any media, and identifies the good, the indifferent and the bad. It also outlines the characteristics and temperaments of the paints.

My aim has been to guide the artist away from poor, often harmful colours towards the more worthwhile. In this context 'harmful' refers to the damage likely to be caused to a painting after exposure to light.

Too often the artist puts enormous creative energy into a piece of work without realising that certain of the colours used will ensure its eventual destruction.

There is no need whatsoever for this situation to exist.

Today, paint manufacturers have a wide choice of lightfast pigments with excellent handling qualities to choose from.

Paints which fade, darken or otherwise deteriorate in colour should be a thing of the past. It would be simplicity itself to offer only colours which are reliable.

Paint manufacturers in general will not bring about the changes needed to protect your work because, in too many cases, the bottom line on the balance sheet is more important than the work of their customers. Shareholders generally come first.

I was once actually told by an area sales manager of a large and reputable company that he could not care less if many of their colours faded because they all sold well. The truth came out after several drinks.

He represented a leading manufacturer of artists' materials who rely heavily on promoting 'tradition' and quality. You would be completely taken aback if I were to mention the name of the company (and I would be taken to court).

Having given that outline I have to say , and stress, that we do have, readily available, a wide range of superb colours which are not only lightfast but which handle extremely well. There most certainly are colormen concerned for the work of their customers.

At the end of the day, paint manufacturers will offer only what you, the artist will purchase. If you select without knowledge you have only yourself to blame if your work subsequently deteriorates.

Choose with care and you will not only protect your work but will play a part in bringing about much needed change.

The fact that there is much confusion caused by the bewildering range of colours available, under an ever increasing list of names, was brought home to me in a forceful way recently.

A friend who paints, a serious and conscientious artist, had in his paint box three reds which would quickly fade, a yellow which would gradually turn green, another which would darken and a white which would form a brittle film prone to cracking. *They were all of 'artist' quality.*

He was shocked when I pointed out these serious shortcomings in his palette and angered when he discovered that he had, at various times, purchased what he believed were three different blues - Winsor Blue, Thalo Blue and Monestial Blue - all in fact were the same: Phthalocyanine Blue.

Such problems should be a thing of the past for the artist. I hope that this book will go a little way towards making them so.

Michael Wilcox

Please note: Colour printing has certain limitations when it comes to the accurate depiction of colour, therefore please do not use the mixes or the colours shown on the labels as accurate guides, they are meant to give an indication only.

Contents

The make up of artists' paint

Paint is essentially a very close combination of pigment and a binder.

Pigments

Pigments are coloured powders produced by a wide variety of methods. They might be based of organic material, synthetically produced or processed from minerals.

Binder

The binder is responsible for holding the pigment together and adhering the paint to the painting surface. In the case of watercolours the binder is a water soluble gum, in oils it is usually linseed oil and in acrylics a water soluble acrylic base which becomes hard on drying.

To the gum, binder and pigment used in watercolours might be added filler, glycerine to hold moisture and prevent cracking, a wetting agent to improve flow and an anti fungal agent. To the linseed oil and pigment in oil paints might be added filler and a small amount of beeswax. The wax improves the handling of certain colours.

Whereas watercolours and oil paints are relatively uncomplicated, acrylics contain a wide variety of additives. To the usual filler might be added preservatives, anti foaming agents and anti coagulants etc.

Filler

Fillers are basically colourless powders, which, above all else, are cheap. Certain colours benefit from the addition of a small amount of filler to prevent stringiness, but the main function of a filler is to fill - to take up space in the tube.

The over-use of a filler will weaken the colour of the paint and affect other qualities. Naturally transparent pigments are made cloudy and dull and the paint will often flow poorly. Although most *student* grades contain relatively large amounts of filler, it is also over used by certain less- caring manufacturers in *artist* quality paints.

The best way to detect the over enthusiastic replacement of pigment with filler is to compare makes. A thin layer painted out with a transparent and standard colour such as Ultramarine Blue should be clear and bright. Compare washes with fellow artists using other makes to discover the clearest. This will almost certainly contain the least filler.

Paint making today

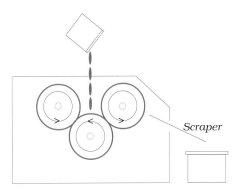

The pigment/binder paste is fed onto the counter rotating rollers of the milling machine. The paste is gradually turned into a paint as each tiny pigment particle becomes coated with the binder.

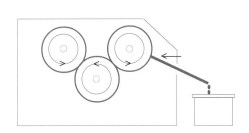

Once the initial stage has been completed, which can take some time, a scraper blade is positioned against the front roller to remove the paint and guide it into a container.

The first part of the process is to blend the pigment and binder together to form a thick paste. Additives such as filler are introduced at this stage.

The thick, heavy paste is then blended into a paint on a milling machine. Heavy, water cooled rollers rotate against each other under pressure. As the paste is forced between them, the individual pigment particles become thoroughly coated in binder and paint is formed. Little grinding of the pigment takes place as it is a very fine powder to start with.

The paint, which forms slowly, is then taken off to be tubed.

Earlier paint making

It usually fell to the apprentice to prepare paints for the Master. Many days could be spent manufacturing the pigment before the actual paint could be made. This was an equally arduous task, involving countless hours with a hand muller and stone slab.

By the time the apprentice became a Master, the characteristics of the limited range of colours in use, were very well known.

All manner of substances, many of them quite bizarre, have been used to give colorants. Lizard droppings from Peru, for example, gave a bright yellow.

The modern artist has much to be thankful for. Never before has such a wide range of excellent and relatively inexpensive colours been readily available.

Before the emergence of the 'Artists' Colorman' (paint manufacturer), some 150 years ago, artists were obliged to make their own colours or employ others to do so.

Great difficulty and expense was incurred in purchasing the raw ingredients. This was followed by a lengthy and exhausting time processing the basic materials and making them into paints.

Poor quality ingredients were sold by dealers and substitutes offered under misleading names. Reliable recipes were often hard to obtain as many art and craft guilds were intent on keeping their formulas secret. Poor general communications did not help the situation.

Pigments were ground into the binder by hand using a stone muller and slab. It could take weeks to properly prepare some colours.

In the constant search for colorants, some very bizarre substances were used. Concentrated cows' urine, ground up beetles, gall stones, lizard droppings and even ground up Egyptian mummies were used. To add to the fun, many of the ingredients were highly poisonous, being based on substances such as arsenic.

A great number of artists either died for their following or became very sick.

Many painters nowadays attribute, in part, the excellence of the work of the earlier masters to the materials and techniques at their disposal.

We are all free to use exactly the same techniques as we have a very full understanding of earlier methods.

When it comes to the availability of suitable pigments and paints, we are indeed very fortunate. Without any doubt at all we now have at our disposal the finest range of colorants that have ever been available. Earlier artists would be very envious of us.

Cross section of a paint film

During the paint milling process, outlined on page 6, the pigment/binder mix enters the rollers in the form of a paste.

After being forced through the rollers, which rotate against each other, the paste gradually forms a paint as each of the tiny pigment particles becomes fully coated in the binder. The binder being a type of gum in watercolours, oil in oil paints etc. As the particles become coated they separate from each other.

If the paint is poorly made the pigment particles are not all coated and tend to clump together. This is the case not only with poorly manufactured paint but often happens when paint is incorrectly mulled by hand and in virtually every case when loose pigment is mixed into a paint.

Such poorly made paints, which are more like a paste than a paint, tend to crack readily on drying. Such cracks start as the paint expands and contracts due to differing temperatures and the dry clumps of pigment start to separate, there being nothing to hold them together.

In well made paint each tiny pigment particle is entirely surrounded by the binder; oil, gum or acrylic. It can take a considerable time to thoroughly mill the paint to this stage.

It is absolutely vital that each individual particle is completely surrounded and therefore separated from its neighbours.

In a poorly manufactured paint the pigment particles tend to stick together in small clumps. As the joints between the particles are dry, there is nothing to hold the groupings together. As the applied paint film expands and contracts the particles tend to separate, causing cracks to begin.

The paint also tends to handle poorly and can be a little like painting with wet salt. An exaggeration maybe, but it can be very unpleasant to work with.

For the reasons outlined, dry pigment should *never* be mixed into a paint without thorough milling by machine or by hand. Dry pigment simply mixed in (however thoroughly stirred) will simply change the paint into a paste.

The use of a mortar and pestle will not alter this situation.

A wash produced with a well made paint should be smooth and even. Excessive graininess or streaking is a sign of a hastily produced product.

Fading and darkening - who really cares?

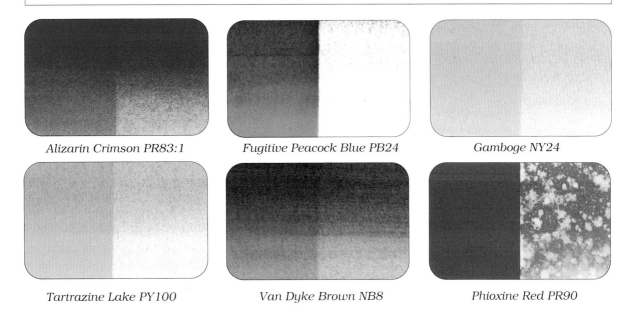

Alizarin Crimson PR83:1 *Fugitive Peacock Blue PB24* *Gamboge NY24*

Tartrazine Lake PY100 *Van Dyke Brown NB8* *Phioxine Red PR90*

The above colours deteriorated during lightfast testing. The amount of light to which they were exposed was equivalent to some 2-3 years in an average room. All were described as being of Artist quality.

Paints can fade or darken for a variety of reasons - through exposure to light, chemicals, pollutants, heat or dampness.

The most common reason for colours to deteriorate is through exposure to light. Chemical changes take place in certain pigments when they are exposed to light which causes the colour to gradually change.

Watercolours are most susceptible to deterioration as they are usually applied in thin layers. The light can attack the pigment from all angles as it reflects from the white surface of the paper.

Oils and acrylics receive a certain amount of protection from the binder and also from the fact that they are often applied fairly heavily.

Apart from possible darkening of the binder, particularly in oil paints, whether or not a paint will fade or deteriorate in some other way depends entirely on the pigment used, some being more dependable than others.

It is my firmly-held view that there is no need whatsoever for artists to be offered colours which will fade, darken or otherwise deteriorate.

The usual reason given by manufacturers for the inclusion of unreliable paints is that they are 'in demand'. The real reason in most cases is that they can 'be sold' to the unsuspecting or ill-informed artist.

I cannot believe that many painters would deliberately choose a colour, however exotic, knowing that it will change and alter their work.

Later in the book we will examine individual colours and pigments. I will give the result of independent testing, as certain manufacturers publish less than accurate (or honest), lightfast ratings for their colours. Others are reliable and do care very much that their colours will not alter.

One of the reasons that so many colours still fade is surely to do with the fact that too large a range is offered by many manufacturers. To produce such a large number of colours, unreliable pigments almost have to be used.

The answer is to use a reduced range of reliable colours and increase your colour mixing skills. Help will be given in this respect throughout the book. Do not rely entirely on suppliers information concerning the reliability of their products. At the end of the day you care more for your work than any colorman.

As mentioned elsewhere, I was actually told by an area sales manager of a large and reputable company that he could not care less if certain of their colours faded because they sold well. All is not as it seems.

Do not buy hype and 'tradition', buy paints made with reliable pigments.

Artist and Student qualities - the differences

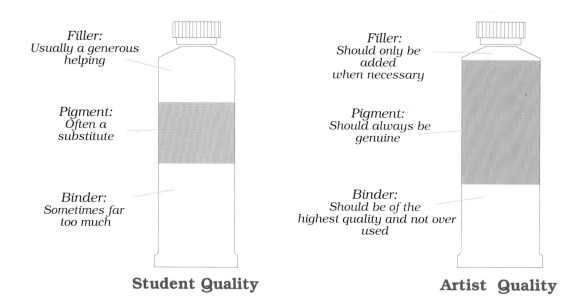

Filler: Usually a generous helping

Pigment: Often a substitute

Binder: Sometimes far too much

Student Quality

Filler: Should only be added when necessary

Pigment: Should always be genuine

Binder: Should be of the highest quality and not over used

Artist Quality

Be wary

Many artists make the mistake of assuming that there are always clear cut differences between the two main categories.

They believe that the Artist grade will always be the more lightfast better quality paint - worthy of the extra cost. This is not necessarily the case and you should be wary about making such assumptions.

Generally speaking the main differences between the two qualities on offer are:

Pigment

Artist quality paints should contain the genuine pigment described in the Colour Name. For example, a colour described as 'Cadmium Red' should contain genuine Cadmium Red pigment. This is not always the case.

Filler

Although a certain amount of filler is necessary in some paints, Student colours often contain an excess; the filler being a cheaper substance than the pigment.

Binder

The extra filler in the Student grade paints often absorbs extra binder, the gum in watercolours, the oil in oil paints etc.

An excess of binder can lead to subsequent darkening in some paints and often causes difficulties in handling.

Student Quality

The pigments used in Student quality paints are usually chosen because they closely imitate the genuine pigment. They can be quite dull in comparison and tend to be weakened due to the extra filler that is often used.

However, certain colours in this grade can be superior to their Artists' quality equivalents. Much depends on the manufacturer.

Imitation Cadmium Yellow, for example, is occasionally sold as Artists' quality, whilst genuine Cadmium Yellow is available from at least one company as a Student colour. Student grades however, should normally be reserved for student work.

Artist Quality

Although the genuine pigments usually used in this grade can be a lot more expensive, they are not *necessarily* suitable for artistic expression.

Many painters believe that the more expensive, Artists' quality paints are lightfast. This is not always the case. A high proportion are prone to fading, some to darkening.

Artists' quality Alizarin Crimson for example will fade when applied as a thin wash and the expensive genuine Vermilion will tend to darken.

Chosen with care and knowledge, these stronger, brighter, higher grade colours are usually worth the extra expense.

Tips when selecting between Artist and Student qualities

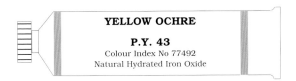

YELLOW OCHRE

P.Y. 43

Colour Index No 77492
Natural Hydrated Iron Oxide

Check the pigments

Always make sure that you know which pigments have been used in your paints and choose accordingly. If the pigments cannot be clearly identified with ease, be suspicious as to the reason.

In the example shown above, the description PY 43 (Pigment Yellow 43), is the most important piece of information as it gives the actual pigment used.

The name 'Yellow Ochre' might or might not be correct (in this case it is) as many fancy and often meaningless names are used.

The Colour Index Number (here 77492) and the chemical class (Natural Hydrated Iron Oxide) are additional but not vital pieces of information. They should, however, at least be published in the manufacturers' brochure.

The earth colours

If you must make savings (and art materials can be rather expensive), select Student quality earth colours. Yellow Ochre, Burnt and Raw Umber and the Siennas.

They may sometimes lack a little clarity in thin washes, (due to the extra filler), but are always absolutely lightfast.

In some cases extra filler is not added because the basic pigment itself is relatively inexpensive. In fact, I visited one company who produced just one quality of each of the earths: Raw and Burnt Sienna, Raw and Burnt Umber and Yellow Ochre.

This same paint, which was of a high quality, then went into both Artist and Student grade tubes, to be sold at widely varying prices. A rare example but it does show that the difference in the grades with the earth colours is not always that pronounced.

A very important consideration is that such colours are absolutely lightfast whatever the grade.

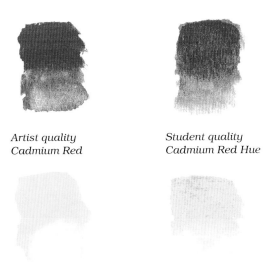

Artist quality
Cadmium Red

Student quality
Cadmium Red Hue

Artist quality
Cadmium Yellow

Student quality
Cadmium Yellow Hue

Select for brightness

For the extra strength of colour and additional brightness, always use artists' quality, (if affordable), for such colours as Cadmium Red and Cadmium Yellow.

Although the differences will not be clearly apparent here, due to the limitations of colour printing, they can be very noticeable in paint form.

Six colours, chosen with care and used with understanding will give several million mixes. 10-12 colours are all that should ever be required

Limited palette

If you work with a limited palette and get to know those colours well you will gradually build up to a range of bright, lightfast, high quality colours.

Colour Mixing

With a knowledge of mixing (now easily gained), you will avoid waste, even the most costly paints will then become relatively inexpensive to work with.

Testing for lightfastness - the work of the ASTM

Suitable Pigments List

Colour Index Name	Lightfastness Category Watercolours	Common Name and Chemical Class	Colour Index Number
PY3	II	Arylide Yellow 10G, with option of adding the name Hansa Yellow Light, arylide yellow	11710
PY31	I	Barium Chromate Lemon, barium chromate	77103
PY34	I	Chrome Yellow Lemon, lead chromate and lead sulfate	77600
PY35	I	Cadmium Yellow Light, concentrated cadmium zinc sulfide (CC) (SM)	77205
PY35:1	I	Cadmium-Barium Yellow Light, cadmium zinc sulfide coprecipitated with barium sulfate (SM)	77205:1
PY37	I	Cadmium Yellow Medium or Deep, concentrated cadmium sulfide (CC) (SM)	77199
PY37:1	...	Cadmium-Barium Yellow Medium or Deep, cadmium sulfide coprecipitated with barium sulfate (SM)	77199:1
PY40	II	Aureolin, with option of adding the name Cobalt Yellow, potassium cobaltinitrite	77357

The above is an extract from the ASTM suitable pigments list for watercolours. From it you will see that Arylide Yellow 10G has a lightfast rating of II: Very Good Lightfastness, Cadmium Yellow Light has been rated as 1: Excellent Lightfastness and Cadmium-Barium Yellow, Medium or Deep has yet to be tested. Reproduced courtesy of the ASTM.

When selecting colours with accuracy, it is vital to be aware of the meaning of the information given on the label. A great deal can be learnt about the paint and the approach taken by the manufacturer. This might seem to be common sense, but a lot can be hidden from the artist - and often is.

There has always been confusion surrounding the naming of paints and pigments. If anything, it has become even worse today. With so many manufacturers offering so many colours, the situation is quite bewildering to most painters.

The same colour name might be used to describe several quite different pigments. Meaningless fancy and trade names abound to add to the confusion.

Substitute pigments are often described in a manner which would suggest that they are genuine. A colour offered as Cadmium Red Light, for example, might not contain a trace of Cadmium Red pigment.

There is further confusion as to what is or is not a student colour. For example, many artists do not realise that the inclusion of the word 'Hue' in a paint name usually identifies it as a student colour. Many think that it means 'colour' or indicates that genuine pigment has been used rather than imitation.

There also remains much ambiguity and misinformation when it comes to declaring the reliability of a particular colour. Pigments known to fade are described by some as being lightfast and several colormen will give different ratings for a pigment purchased from the same manufacturer.

Colours which have been known for decades to fade or deteriorate in some other way are still being sold to the unwary as being of 'Artist' quality. The excuse offered is that a 'demand' exists for the colour. A demand from the unwary perhaps, because few will really wish to purchase colours which will lead to the deterioration of their work.

In an heroic effort, on behalf of the artist, past and present members of an ASTM (American Society of Testing and Materials) subcommittee on artists paints have brought partial order to the scene. I say partial, because not all manufacturers work to the ASTM guidelines and there is still much to do in other areas.

All aspects of paint labelling have been fully explored by the sub - committee and firm guidelines laid down.

Most importantly, individual pigments have been subjected to independent lightfast testing and lists are published giving those colorants which are suitable for use in 'Artist' quality paints.

The subcommittee feel, quite rightly that colours described as being of artist quality should be lightfast. They have also laid down recommendations for accurate and informative paint labelling. These are outlined on the following pages.

There are few excuses for misleading or confusing information being available today. But you would probably not be reading this book if the situation was as it should be.

Labelling: colour names and health information

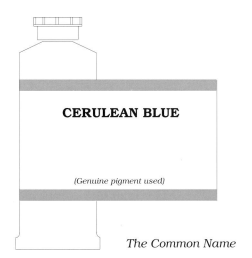

CERULEAN BLUE

(Genuine pigment used)

The Common Name

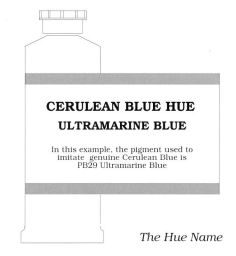

CERULEAN BLUE HUE

ULTRAMARINE BLUE

In this example, the pigment used to imitate genuine Cerulean Blue is PB29 Ultramarine Blue

The Hue Name

The new approach to paint labelling set down by the ASTM sub-committee on artists' paints, outlines the following:

The Common Name

This will identify the established, commonly used name for a colour.

In the example shown above, the widely used and accepted Common Name would be:

CERULEAN BLUE

The Hue Name

A lot of confusion surrounds the use of the word 'Hue' after a colour name. Various interpretations abound - from it being another word for 'colour', to 'Hue' meaning that the 'correct' ingredients have been used.

In fact, it simply means that the manufacturer has used *substitute* pigments in order to *imitate* the *genuine* pigments.

This is usually a good indication that the colour is of Student quality. But it is not always the case. A manufacturer might, for example, avoid the use of genuine Vermilion pigment in a watercolour, knowing that it tends to darken on exposure to light. A substitute ingredient might be used which is in fact far superior to true Vermilion in reliability.

In the case of an imitation Cerulean Blue, manufactured from Ultramarine Blue (a common practice), the colour would be called:

CERULEAN BLUE HUE

The 'Hue Name' must be followed by the 'Common Name' of the actual pigment used. In the above example, Ultramarine Blue was the pigment used to imitate Cerulean Blue, the full name would therefore be:

CERULEAN BLUE HUE
ULTRAMARINE BLUE

This would be followed by the name or names of the ingredients.

Trade names

If a manufacturer wishes to use a trade name instead of the Common or Hue Name, the particular colour shown above might be called:

SMITH'S BLUE
ULTRAMARINE BLUE

Health information

When supplied, this is to be found on the back of the tube. Artists are becoming more aware of the toxicity of certain paints and information is becoming more widespread.

The subject is not covered in this book.

Lightfast information: identifying the pigments

Lightfast information

Today, the ingredients of many general products (food etc.) are clearly given. We have a right to demand such information.

The paints used by artists are only now beginning to be properly labelled to show the ingredients, and then not by all manufacturers. It is not satisfactory that materials which are often rather expensive and, more importantly, can dramatically affect the life of a painting, are still often poorly and even misleadingly labelled. To the caring artist, knowledge of the pigments employed in any colour is vital.

Once again the work of the ASTM subcommittee has given direction. They have provided a common understanding for the naming of colours and for the identification of the pigments used. They have, in addition, carried out independent lightfast testing of the major pigments.

Lightfast ratings

Lightfastness I Excellent Lightfastness.

Lightfastness II Very Good Lightfastness.

Lightfastness III Fair Lightfastness.

Lightfastness IV Poor Lightfastness.

Lightfastness V Very Poor Lightfastness.

Only pigments which have been rated as either **I** or **II** are eligible for inclusion in the 'Suitable pigments list'. Artist quality paints must rate as either ASTM I or II. At last it has been recognised that it is a contradiction in terms to describe fugitive colours as being of artist quality.

Mixed Pigments

Where two or more pigments are blended in one colour the ASTM rule is that the lightfast rating of the paint must be no higher than the *lowest* rated pigment.

If, for example, a green was mixed from a blue with a rating of I and a Yellow rated as II the overall rating must be II, that of the lowest rated pigment. Look for the ASTM lightfastness rating on the tube - it means a great deal. There are still many manufacturers who do not use these guidelines and some of them will sell you almost anything.

Identifying the pigments

If you are going to choose your paints with care, you must be able to identify the pigments used with accuracy.

Colour Index Name

This will identify very precisely the pigment used in any paint. This is more important than the *Common* or *Trade* name as described on the previous page.

The colour Index name is broken down into three parts: The type of dye or pigment, the hue and an assigned number.

For example, Cadmium Yellow Light is:

Pigment Yellow 35

The word *Pigment* identifies the type of colorant. *Yellow* the hue and *35* the assigned number. This might be written as *PY35*. Cobalt Blue is *Pigment Blue 28 or PB28* and Mars Red *Pigment Red 101 or PR101*.

All colours are similarly abbreviated. PO stands for Pigment Orange, PG for Pigment Green and PW for Pigment White etc.

If such a description is not given on the actual tube, I would suggest that you do not purchase the paint. It is *that* important.

The Colour Index Number

You might also find an identifying number in the literature. This is seldom printed on the tube. As examples - Cadmium Yellow Light (PY35) has a Colour Index Number of 77205 and the CIN of Cobalt Blue (PB28) is 77346.

Chemical Description

A simple chemical description of the pigment should also be included on the label. To remain with our examples: Cadmium Yellow Light (PY35) has a Chemical description of *'Concentrated Cadmium Zinc Sulphide'* and Cobalt Blue (PB28) is described chemically as *'Oxides of Cobalt and Aluminium'*.

If you select paints described under the requirements of the ASTM, you can be sure of exactly what you are buying.

Creative people often avoid detail such as I have given here. However, the only way that you can protect your work is to come to terms with this area. Perhaps read these pages several times. As you progress through the book it will all become familiar to you.

Acceptable pigment identification

If you wish to avoid colours which are prone to fading or deteriorating in some other way, it is vital to be able to identify the actual pigments which have been used.

Unfortunately not all manufacturers follow the guidelines set down by the ASTM, Although this does not prevent them from producing some excellent colours.

With a little practice you will be able to develop an 'eye' for deciphering the variety of paint labels.

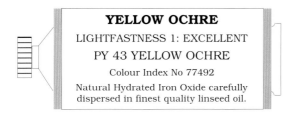

YELLOW OCHRE

LIGHTFASTNESS 1: EXCELLENT

PY 43 YELLOW OCHRE

Colour Index No 77492

Natural Hydrated Iron Oxide carefully dispersed in finest quality linseed oil.

In the above example full information has been given for a reliable pigment in any medium, in this case oil paint.

YELLOW OCHRE

LIGHTFASTNESS 1: EXCELLENT

PY 43 YELLOW OCHRE

In this case, less information has been provided, but this is acceptable as the Colour Index Number is rarely given and the binding agent, oil, gum etc. is not always mentioned. The essential information on the pigment used has been made clear.

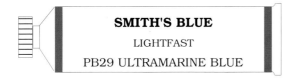

SMITH'S BLUE

LIGHTFAST

PB29 ULTRAMARINE BLUE

This is acceptable as the vital information on the pigment used has been provided.

The colour name, although not ideal, can be lived with, 'Ultramarine Blue', or 'French Ultramarine' would have removed any possible confusion.

SMITH'S YELLOW

ARYLIDE PIGMENT

This approach is definitely *not* acceptable. The description 'Arylide' is too vague as it covers a wide range of pigments.

It might be that the reliable PY3 Arylide Yellow 10G has been used or it could equally refer to PY1 Arylide Yellow G, a disastrous substance known to fade.

Terms such as 'Arylide pigment', 'Arylide Base' or 'Hansa Pigment' give no indication whatsoever of the actual pigment which has been used. To my mind, it is a cover up.

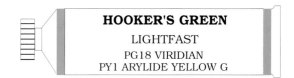

HOOKER'S GREEN

LIGHTFAST

PG18 VIRIDIAN

PY1 ARYLIDE YELLOW G

The above example, which appears on an actual paint label, illustrates the need to always check the reliability of the ingredients. (Pigment check lists are provided throughout this book.)

The PG18, Viridian, will not fade but the PY1 Arylide Yellow G definitely *will*, causing the green to change in hue. The mix is erroneously described as being lightfast, but a lot of errors seem to appear on labels.

CERULEAN BLUE

ARTIST'S QUALITY

Various makes give no indication whatsoever as to the pigments used. In the above example, the colour might be produced from PB35 Cerulean Blue, but equally it might be an imitation containing inferior pigments. Do not be misled by the description 'Artist's quality'.

If the manufacturer was proud of the pigment, you would be the first to know.

Typical labelling

Artist Quality

Even if the labelling does not conform to the standards of the ASTM, the information given on the label should at least give an accurate lightfastness rating and identify the pigment used. Paints offered without such minimum information should be avoided. The Colour Index Number is seldom given. The Chemical description, where given, might not always be accurate unless ASTM standards are being adhered to.

Common Name............................

Lightfastness rating...................

Colour Index Name.....................

Colour Index Number..................

Chemical description.................

CADMIUM YELLOW

LIGHTFASTNESS I: EXCELLENT

P.Y.35

COLOUR INDEX No.77205

Concentrated Cadmium Zinc Sulphide

Student quality

Student quality colours are often poorly labelled.

Before making a purchase I would suggest that you ensure that at least the pigment used is clearly identified by the Colour Index Name and that the lightfastness rating is given.

Some manufacturers do give accurate and useful information, but they are in the minority.

Hue Name....................................
Common Name
for the pigment............................

Lightfastness rating...................

Colour Index Name.....................

CADMIUM YELLOW HUE

ARYLIDE YELLOW G

LIGHTFASTNESS - FUGITIVE

P.Y.1

Specialist labelling

Additional information to that so far outlined might also be provided.

In the case of our own School of Colour paints, where the emphasis is on accurate colour mixing, the 'colour type' is given above the Common Name, together with the opacity of the paint. We feel that such information will be of more immediate use than the Common Name, which is given, together with all other information required by the ASTM standards.

There are many cases of colours described by fanciful names such as 'Oak Leaf Green' and 'Mountain Grey'. The Common Name is seldom given.

To my mind such an approach can only be regressive. I would suggest that you do not encourage it.

ORANGE-YELLOW

OPAQUE

CADMIUM YELLOW

LIGHTFASTNESS 1: EXCELLENT

P.Y.35

COLOUR INDEX No.77205

Concentrated Cadmium Zinc Sulphide

Transparent, semi transparent and opaque paints

Over the centuries a range of pigments has been developed to give artists the colours they require. A very important consideration has always been the characteristics offered by a particular pigment, is it transparent, opaque or somewhere in between?

Earlier artists were more aware of the qualities offered by their paints - perhaps they cared more for the craft of painting than many do now.

They prized transparent colours, for example, because they were of special value in glazing. Opaque colours were selected for other techniques.

Without being aware of the different handling characteristics of their paints, many of today's artists attempt to cover previous work with transparent paint or to apply thin glazes with opaque colours. In order to extract the maximum from your paints it is important to recognise the differences.

Most manufacturers give information on opacity in their literature, usually in the form of various symbols. The most common categories are: transparent, semi-transparent and opaque. Some companies take this a little further and include semi-opaque.

Rather than rely on the judgement of others , it is a useful exercise to decide on opacity yourself.

A simple test is to apply an equally thin layer of each of your colours over a black line. A waterproof black marker can be used to lay down the line.

As you will see in the example, it is easy to decide on opacity.

If the black line appears sharp and dark, the paint is transparent. If it is covered, the paint is opaque. Semi-transparent or semi-opaque colours will also reveal themselves.

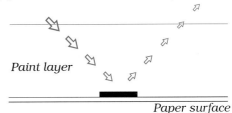
Paint layer
Paper surface

Transparent paint will allow the light to travel through the layer, revealing underpainting, (in this case the black line).

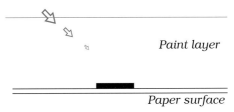
Paint layer
Paper surface

Semi-transparent or semi-opaque paint will absorb much of the light on its journey through the paint.

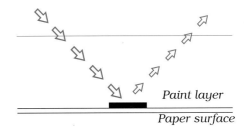
Paint layer
Paper surface

In the case of opaque paint, the light only penetrates a short distance into the paint. Most is reflected near the surface.

Transparent paints must be selected if you are going to mix by glazing; that is, painting in thin layers, so allowing the underpainting to show through.

Semi-transparent paints are less efficient when glazing but will do a reasonably good job if applied thinly. This is particularly so if the paint is of a good strength and not packed with filler.

Semi-opaque paints can be used for covering and also for scumbling. (Paint applied in broken layers, the undercolour being allowed to show through the breaks).

Opaque paint comes into its own when you need to cover previous work. Certain opaque colours, if they are well made, can also be applied in thin, reasonably transparent layers. Artist quality Cadmium Yellow, for example, can be used in this fashion.

Staining and non-staining colours

You can determine the staining power of a watercolour or gouache by following the procedure outlined here.

It is less easy when working with acrylics, oils or alkyds. With these media, apply small areas of colour to the painting surface to be worked on, leave for a short time and remove with the appropriate dilutant. The staining colours will leave behind a greater trace of colour than the non stainers.

1

When testing watercolours or gouache, apply a small patch of each colour onto the type of paper that you normally work on.

2

After the paint has thoroughly dried, soften it with a clean wet brush. Wash the brush between colours to avoid contamination.

3

Remove the softened paint by washing it with a very wet sponge or by holding the paper under a running tap.

4

The staining colours will reveal themselves as the paper dries.

Due to the nature of the pigment, certain colours will stain the surface to which they are applied. Some will actually stain colours which are applied over or alongside them.

If you have ever painted a layer of white, for example, over a red and had the white turn pink, you will have experienced a staining colour. In this example, the red will have stained the white above the red, and possibly the surface beneath the red.

Staining colours can be a particular problem for the watercolourist.

As soon as the colour is applied it stains the paper and is impossible to remove. Mistakes remain mistakes.

However, used with care, staining colours can leave behind very bright, clear highlights after the actual paint has been carefully lifted with a brush or sponge. Do not be put off by the fact that certain colours are capable of staining as many of them have admirable qualities in other areas.

A simple test to determine which watercolours will stain is to apply an area of paint, allow it to dry and then gently wash off as much colour as possible. Non stainers will leave little trace, stainers will mark the paper.

It is always better to do your own testing rather than rely on the reputation of certain colours. Ultramarine Blue for example, is known to be a non stainer, yet in recent experiments I found one brand which stained the paper immediately.

If the paint is applied very wet it tends to have greater staining power than if applied less so. The extra water tends to take the stain deeply into the fibres of the paper.

The fewer colours you work with, the more you will be able to identify the stainers.

Colours which are capable of staining are not only of interest to the watercolourist, as they appear in all media and have to be taken into account. However, they do have more of an effect when working in wet media.

Pigments, dyes, binders and lake colours

Pigments: Dyes

There is often confusion about the differences between a dye and a pigment.

Dyes or stains are substances that can penetrate other materials and become a part of them, sharing their colour.

Pigments on the other hand, colour surfaces by simply lying on them.

To prevent the pigment becoming easily removed it is often attached with a binder, a substance that will not only keep the pigment particles together but will also fix them to the painting surface.

Binders

A wide range of sticky substances have been, and still are, used as binders. Amongst them are: blood, grease, saps, honey, concentrated urine, vegetable and animal oils, eggs, lime, plastics, milk extracts and waxes.

Some rather unusual mediums have been developed. Indians from the northwest coast of America for example, made a type of egg tempera by chewing salmon eggs wrapped in cedar bark. The egg oil, saliva (and probably resins from the bark) made up a reportedly good medium - I have yet to try it for myself!

Binding methods

There are three principal methods of binding pigments. Firstly, the binding medium can be applied followed by the pigment. This is the case with fresco painting, where the plaster, which acts as the binder, takes the unbound pigment and holds it in place. In a similar fashion artists of old would sometimes take certain coarsely ground pigments and sprinkle them onto a wet binder where they sparkled brightly.

Secondly, the pigment and the binding medium can be closely bound together. This is the most common method of applying colour in paint form. Once the medium - oil, glue, egg, acrylic, etc. has dried and hardened it holds the pigment safely in place.

The third method is to apply the pigment first, followed by the binder, as in pastel painting, where a fixative is applied on completion of the application of the unbound pigment. A very weak gum is used to hold pastels together for ease of application only, rather than as the final binder.

The Early Egyptians developed some very sophisticated pigments, amongst them the first Lake colours.

Lake colours

The early Egyptians, who invented many colours, produced a range of clear, clean coloured pigments. Wishing to add to this list, they sought a way of using the dyes discovered by their textile industry, colours such as the red obtained from the root of the madder plant.

However a dye cannot be simply mixed with a binder and used as a paint. To create the coloured pigment particles required for paint manufacture, the dye was used to colour an otherwise colourless pigment.

The Egyptians discovered a method of dying colourless, inert pigments such as chalk. The process, which requires much skill, can be likened to the dying of cloth.

Many modern pigments are produced in this way to take advantage of the wide range of dyes now available. Such pigments are known as 'Lake' colours.

A paint described say, as 'Madder Lake' will have as its pigment a colourless base which has been dyed to give the final hue. I used to think that it was far more romantic than that, given some of the lovely colour names.

Viscosity: binder separation

Viscosity

The most obvious difference between the various media as far as the artist is concerned is the viscosity they impart to the paint.

The stickiness, thickness, thinness, oiliness or otherwise can be adjusted to a certain extent by additives.

As over-use of certain additives can cause damage to the paint film, it is better to choose a paint (where possible) manufactured to a consistency that you find pleasant to use.

Between the extremes of being overbound (oozing with oil or gum), and underbound (too thick and heavy to leave the tube without difficulty), there lies a range of viscosities depending on the manufacturer.

It would obviously be impossible to suit everyone's ideal , so choose a paint which will require the minimum alteration for use.

Perhaps fellow artists will allow you to try their paints if they are different to your own. This will avoid the necessity of squeezing colour out whilst hiding behind the paint rack in your local art store.

To help in this area, there are both thickened and easy-flow paints (in certain media) on the market.

Also available are various additives which will alter the viscosity of a paint. These should be used with caution as they are not all beneficial.

An oil paint additive containing Dammar, for example, should not be used if the final painting is to be varnished using dammar varnish. If the work has to be cleaned in the future, the turpentine used to soften the dammar varnish will also soften the dammar in the additive and could lead to the removal or damaging of the paint.

Binder separation

It can be particularly annoying to squeeze paint from a tube and find that it is mainly gum or oil.

If a paint is overbound (contains too much binder), it can represent a poor buy as most of it is unusable. It will also handle with difficulty and give poor results.

A certain amount of separation in the tube is common and should not be a cause for concern if it is minimal.

If a great deal of binder leaves the tube or if only gum or oil leave the tube and the residue is particularly hard I suggest you return the product. Certain brands tend to be more overbound than others.

A certain amount of separation can be expected with many paints and should not cause concern. A few drops of binder before the paint arrives should be acceptable. An excessive amount indicates a poorly made paint.

Almost as frustrating is underbound paint. This can be so thick and heavy that it is difficult to squeeze from the tube.

If there is a danger of the tube splitting from excess pressure, or you have to resort to using a rolling pin, I would suggest returning the product for a replacement or refund.

You might well be told that the heaviness is due to densely packed pigment and that it is a sign of quality. Reference might well be made to advertising in which paints are described as being 'packed with pigment'.

Ignore such explanations - a well made paint should at least leave the tube without the use of an industrial press.

Hardened paint - removing a stuck cap

Carefully cut down the centre of the tube and across each end (1). Open the 'flaps' and fold back (2). This will reveal the hardened paint which can then be used as a pan colour. This approach should only be attempted if you are confident with a knife

Hard paint in the tube

If air is allowed to enter the tube the paint will harden. This usually occurs when the cap has been left off for any length of time. A split in the tube will also cause the same problem.

Nothing can be done in the case of oils or acrylics but watercolours can be used after hardening.

One approach is to open the bottom of the tube and insert the brush. This is a particularly messy method of working and only a small amount of paint can be removed without considerable effort. The main drawback however is that brushes are easily damaged against the rough edges of the tube.

A better method is to open up the tube in much the same way as the space shuttle opens. With a sharp knife or scalpel, cut down the centre of the tube from top to bottom. Cut across the top and bottom of the tube from one side to the other and open the 'flaps'.

Fold the flaps under the tube, if you like to be neat, and you will have full access to the paint. It will be very much the same as working with a pan.

With some brands the lining of the tube tends to separate and remain on the paint. This is easily scrapped off before using. I would suggest when using such colours that you dampen the paint some time before using it. This will ensure that the paint is easily removed by the brush.

Dried paint can be harder to soften than pan colours due to the slightly different make-up of their respective binders.

Recently purchased paint found to be hard in the tube should be immediately returned for a replacement.

Try holding the cap in hot water for a short time in order to expand it before removing with the help of pliers or the protection of a piece of cloth.

Removing stuck caps

Little is worse than a half hour wrestling match with your paints before starting to work. Some caps seem designed to be put on once and remain there. Fortunately some manufacturers realise the problem and provide extra large caps for added grip, or slots to take a coin.

In the days of metal caps, a lighted match could be held under the cap for a few seconds. The expanded cap could often then be removed. Fingers could also be burnt at the same time.

This method is not to be recommended with today's plastic caps as they will simply melt or burst into flames. They can however be dipped into very hot water for a short while to expand the cap. Pliers are recommended to hold the hot cap. In order to help avoid the situation, it pays to wipe the threads on the tube with a tissue or cloth before replacing the cap.

Introduction to yellows

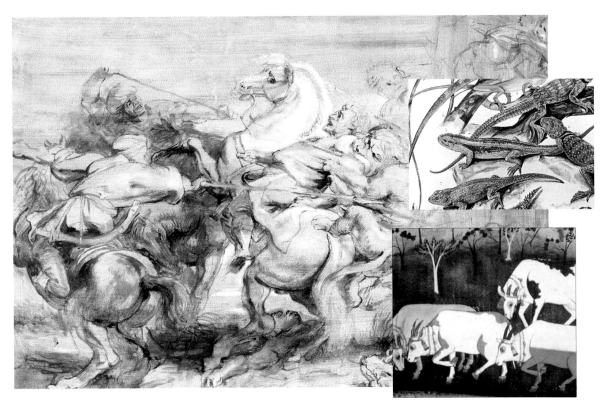

Where yellow was used as a hue, rather than to imitate gold, it was usually employed in a rather subdued way when compared to modern practices. Painting by Peter Paul Rubens: The Lion Hunt, courtesy The National Gallery, London.

All manner of substances were employed to give yellow pigments and dyes, from lizard droppings to tortoise bile to concentrated cows' urine.

Over the ages our approach to the use of yellow in painting has changed. In ancient and Medieval times the main use of a yellow paint was to imitate, as closely as possible, gold.

Of secondary importance was its ability to modify other colours when used in mixing. At the bottom of the list was the use of yellow to depict yellow objects. This has now become our principal use of the colour.

The strongest (unmodified) yellow used in earlier times for most purposes was usually Yellow Ochre. The type of bright yellow we seek today was usually thought to be disruptive to the balance of a painting. The book illuminator however, required very bright yellows for a different type of work.

A wide range of substances have been employed to give yellow colouring materials. Yellows have been produced from fish and animal bile, gall stones, lizard droppings and a wide variety of vegetable extracts.

A clear, bright yellow was obtained from concentrated cows urine, this was exported from India, usually mixed with mud into small lumps.

For certain types of work a metallic effect could be achieved by whipping mercury into egg yolk and adding a suitable dye.

An arsenic - based compound gave a strong bright yellow but caused a lot of sickness and ensured the early demise of many an artist. Things are much improved now, thank goodness, and the colours are far more reliable and safer to use.

Nowadays a wide range of yellows is available which vary from the absolutely lightfast to the fugitive. It certainly pays to understand the differences as you could very easily purchase a yellow which has a bright but temporary life, as will the painting in which it was used.

Arylide Yellow 10G or Hansa Yellow Light

**ARYLIDE YELLOW 10G
or HANSA YELLOW LIGHT**
Lightfastness
Watercolours II: Very good
Oils II: Very good
Acrylics II: Very good
Gouache I: Excellent
Alkyds II: Very good
PY 3

In your search for suitable colours you will almost certainly have come across the simple pigment description 'Arylide'.

By itself the name is meaningless because it encompasses fugitive, worthless pigments such as **PY1** Arylide Yellow G as well as the superb **PY3** Arylide Yellow 10G. Unless the actual *Colour Index Name* is given on the tube (PY1, PY3 etc.), treat with extreme caution.

The manufacturer knows the actual variety of Arylide Yellow that you are being offered, so why are they not telling you?

The Common Name of this colour is Arylide Yellow or Hansa Yellow Light but it is often simply called Lemon Yellow. Reasonably transparent but this can vary depending on whether or not filler has been added.

Will cover well when applied even moderately heavy.

Good tinting strength makes this a useful colour when mixing. Dries quite well as an oil paint.

If you are looking for a lightfast green-yellow (Lemon Yellow), with good handling qualities, reasonable transparency and strength, this colour will stand you in good stead. It should also be less expensive than the alternative Cadmium Yellow Lemon.

Recommended

Mixing tips

This is a particularly useful yellow for colour mixing purposes. It possesses good tinting strength and holds its own in any mix.

The fact that it covers well when applied at all heavily, and at the same time will give reasonably transparent washes in thin applications, adds to its value.

Being a definite green-yellow it will give bright, clear greens (when applied thinly)

with Phthalocyanine Blue,

bright, semi-opaque greens with Cerulean Blue

and dark semi-transparent greens with Ultramarine Blue.

Please see next page for mixing complementary.

Technical information: *Common Name* - Arylide Yellow 10G or Hansa Yellow Light. *Colour Index Name* - PY3. *Colour Index Number* - 11710. *Chemical Class* - Arylide Yellow. *ASTM Lightfast rating* - In oils, watercolour, acrylics and alkyds II : Very Good, in Gouache I : Excellent. *Transparency* - Semi Transparent. *Drying* - Average drier as an oil paint.

Aureolin (Cobalt Yellow)

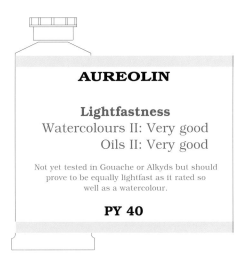

AUREOLIN

Lightfastness
Watercolours II: Very good
Oils II: Very good

Not yet tested in Gouache or Alkyds but should prove to be equally lightfast as it rated so well as a watercolour.

PY 40

Gives an unusual range of values, from dark and heavy to transparent and bright.

Aureolin, or Cobalt Yellow as it is also called, is a reliable, bright, transparent yellow. The genuine colour can be rather expensive.

It gives very clear washes when applied thinly and, as such, is particularly useful when working in washes or mixing by glazing. However, it takes on a heavy, almost leathery, appearance when used thickly. This limits its appeal. Quite strong in tinting power it will add its weight in a mix. Covers well when heavy.

Blended with other, equally transparent colours it can give excellent results, but it seems a waste to use it as a general yellow when mixing with more opaque paints. Lightfast but can be affected by weak acids and alkalis, therefore always use an acid free support, (paper, board or canvas).

Imitations on the market are produced from such pigment mixtures as Mars Yellow (PY 42) and Arylide Yellow (PY3). They are never quite as transparent. Always buy the genuine article if you want a truly clear, bright yellow (in thin applications).

Recommended

With a lightfast rating of II in watercolours you can be sure that this colour will not let you down .

Mixing tips

manufacturer. Whichever version you have, exploit its transparency to the fullest. Either use alone or, if mixed, choose other clear colours as mixing partners.

Delicate neutral (dulled) yellow oranges result when blended with Burnt Sienna (also transparent).

The colour varies between a slightly green-yellow to an orange-yellow depending on

Will give very clear mid to dark greens with Ultramarine Blue (transparent).

Covers well when heavy but very transparent when thin.

Technical information: *Common Name* - Aureolin, with option of adding the name Cobalt Yellow. *Colour Index Name* PY40. *Colour Index Number* - 77357. *Chemical Class* - Potassium Cobaltinitrite. *ASTM Lightfast rating* - In oils and watercolour, II Very Good (Not yet tested in Gouache or Alkyds but will almost certainly be found to be lightfast). *Transparency* - Very good in thin applications. *Staining power*- Non - staining. *Drying* - Dries quickly (to a hard film) as an oil paint. Average oil content

Cadmium Yellow Light

**CADMIUM YELLOW
LIGHT**
Lightfastness
Watercolours I: Excellent
Oils I: Excellent
Acrylics I: Excellent
Gouache I: Excellent
Not yet tested in Alkyds but should prove to be
equally lightfast.
PY 35

Genuine Cadmium Yellow Light (when well produced) is one of the most important, if not *the* most important, light yellows of the palette.

A strong, bright, clean hue noted for its opacity. Although this latter quality allows for the covering of earlier work, its strength will allow you to produce reasonably clear washes and layers when applied thinly.

Although absolutely lightfast under normal conditions, dampness can cause the colour to fade. This can be a problem in areas of high humidity. Depending on the manufacturer, the colour will either be biased towards green or orange.

Be wary of imitations, there are many on the market and most tend to fade. Look for the pigment description **PY35**.

Do not worry if a little PO 20 (Cadmium Orange) has been added or if a light version of PY37 (see next page), has been used as all of the Cadmiums are from the same 'family'.

If a pigment number is not given I suggest that you do not purchase. Ask yourself why it is not given.

Recommended

Cadmium Barium Yellow Light is an equally reliable, close relation. It should be cheaper than the chemically pure version (PY35). Look for the Colour Index Name PY35:1

As with Aureolin, the colour can be biased towards either green or orange.

Mixing tips

If biased towards green you will obtain bright greens with a green-blue such as Cerulean (another opaque colour), and dull oranges with any red.

If your version leans towards orange, expect bright oranges when mixed with Cadmium Red Light and dullish greens with Cerulean Blue.

A strong, bright, opaque yellow giving a useful range of values. Covers well but its strength will allow reasonably clear thin layers.

Technical information: *Common Name* - Cadmium Yellow Light. *Colour Index Name* - PY35. *Colour Index Number* 77205. *Chemical Class* - Concentrated Cadmium Zinc Sulphide. *ASTM Lightfast rating* - In oils, watercolour, acrylics and gouache I: Excellent (Not yet tested as an Alkyd but will almost certainly be found to be lightfast). *Transparency* - Opaque. *Staining power* - Slight. *Drying* - Dries slowly as an oil paint to a fairly strong film.

Cadmium Yellow Medium

CADMIUM YELLOW MEDIUM

Lightfastness

Watercolours I: Excellent

Oils I: Excellent

Acrylics I: Excellent

Gouache I: Excellent

Not yet tested in Alkyds but should prove to be equally lightfast.

PY 37

All Cadmium Yellows (Light, Medium, Deep and Lemon) are variations of the same basic pigment. All are equally reliable and handle very well. Cadmium Yellow Medium, often simply called Cadmium Yellow is a clean, bright, opaque orange-yellow.

As with other members of this family, as a watercolour it can fade, sometimes quite dramatically when exposed to light under humid conditions. This should not normally be a problem as paintings are usually protected within a frame.

Due to the popularity of this superb colour there are many imitations on the market. Any colour described as 'Cadmium Yellow Hue' is a student colour. Apart from one or two notable exceptions these are invariably cheap, relatively dull alternatives which will fade rapidly. As with all colours, look for the ingredients first and foremost. Unless the tube (not just associated literature) indicates clearly that **PY37** is the one and only pigment used, replace it in the paint rack.

Recommended

Cadmium Barium Yellow Medium is an equally reliable, close relation. It should be less expensive than the chemically pure version (PY37). Look for the Colour Index Name PY37:1

Leaning more towards orange than Cadmium Yellow Light does means that it also leans further away from green.

Mixing tips

Therefore expect duller greens when mixed with a green-blue such as Cerulean. The green will be duller than that produced using the Light version as this colour 'carries' less green. As both are opaque the resulting mix will also be opaque.

For a similar but semi-transparent green mix with Phthalo Blue (transparent).

Or for a darker semi-transparent green, blend with Ultramarine Blue which is transparent and leans away from green.

Technical information: *Common Name* - Cadmium Yellow Medium. *Colour Index Name* - PY37. *Colour Index Number* 77199. *Chemical Class* - Concentrated Cadmium Sulphide. *ASTM Lightfast rating* - In oils, watercolour, acrylics and gouache I: Excellent (Not yet tested as an Alkyd but will almost certainly be found to be lightfast). *Transparency* Opaque. *Staining power* - Slight. *Drying* - Dries slowly as an oil paint, forming a fairly strong film.

Cadmium Yellow Deep

CADMIUM YELLOW DEEP
Lightfastness
Watercolours 1: Excellent
Oils 1: Excellent
Acrylics 1: Excellent
Gouache 1: Excellent
Not yet tested in Alkyds but should prove to be equally lightfast.
PY 37

As has been mentioned, all Cadmium Yellows are part of the same family with similar chemical make up. Cadmium Orange and Cadmium Red are part of the same group. They give us an invaluable range from a light green-yellow to a vivid strong orange-red.

Do not be deterred from using these superb colours by reports of their toxicity. As with all artists' paints, used sensibly they will not cause the slightest harm.

As the Cadmiums have such a good reputation, some manufacturers cannot resist imitating. Look out for combinations such as PY1 Arylide Yellow and PO1 (Pigment Orange 1) or PY74 Arylide Yellow and PR4 (Pigment Red 4). They are inferior substitutes which will fade.

If the Colour is described as being Cadmium Yellow Deep and contains such pigment combinations (as some do) an attempt has been made to deceive you. You will know how to respond.

Cadmium Red Deep (Azo) is invariably an example of the use of inferior pigments sold as the genuine article. Always buy the true colour.

Recommended

Cadmium Barium Yellow Deep is an equally reliable, close relation. It should be cheaper than the chemically pure version (PY37). Look for the Colour Index Name PY37:1

Mixing tips

As any reader of my book 'Blue and Yellow Don't Make Green' will know, all yellows reflect three main colours, yellow, green and orange.

As a yellow moves towards orange its orange content naturally increases. This is to the cost of its green content, which is reduced.

Therefore a definite orange-yellow such as this will give dark greens when mixed with any blue.

If the blue should also contain only a tiny amount of green, as is the case with Ultramarine Blue, the result will be very dark.

Slightly brighter greens result when mixed with a green-blue such as Cerulean.

Personally I find both Cadmium Yellow Deep and Medium rather superfluous.

A Cadmium Yellow Light which leans towards orange (rather than green), together with Cadmium Red Light will give a wide range of such orange-yellows.

Technical information: *Common Name* - Cadmium Yellow Deep. *Colour Index Name* - PY37. *Colour Index Number* 77199. *Chemical Class* - Concentrated Cadmium Sulphide. *ASTM Lightfast rating* - In oils, watercolour, acrylics and gouache 1: Excellent (Not yet tested as an Alkyd but will almost certainly be found to be lightfast). *Transparency* Opaque. *Staining power* - Slight. *Drying* - Dries very slowly as an oil paint forming a strong film.

Cadmium Yellow Lemon

**CADMIUM
YELLOW LEMON**

Lightfastness
Watercolours I: Excellent
Oils I: Excellent
Acrylics I: Excellent
Gouache I: Excellent

PY 35 or PY 37

This is the lightest member of the Cadmium Yellow family.

A first-rate very reliable green-yellow which has performed extremely well in all lightfast testing.

Although it is an opaque colour, its strength allows for reasonably clear washes when applied very thinly. A well made product will not become grainy when used this way.

An intense yellow with a good range of values and strong in tinting strength.

I would suggest that you choose either this colour or Arylide (Hansa) Yellow, *page 23*, as your green-yellow (Lemon Yellow).

You will not require both colours unless for very specific reasons. In fact we tend to purchase and attempt to use far too many colours.

This keeps the colormen happy but can only lead to confusion when mixing, and unnecessary waste. One good

green-yellow, a reliable light orange-yellow such as Cadmium Yellow Light and possibly a neutral orange-yellow such as Yellow Ochre will give great versatility and range to the palette, as well as protecting your pocket.

The word 'Azo' (meaningless in itself), after the name 'Cadmium Lemon' indicates that the colour is an imitation. With such a vague description such colours are best avoided.

Recommended

Mixing tips

As with Arylide (Hansa) Yellow the mixing complementary is a reddish violet. If you are using a School of Colour mixing palette you will find this colour directly opposite.

Green-yellow and reddish-

violet will darken each other without causing a major change in direction. They will also produce some valuable coloured greys when blended in near equal intensities.

Technical information: Please refer to information covering Cadmium Yellow Light (page 25) and Cadmium Yellow Medium (page 26). This colour is a lighter and greener version of one or other. *Drying* - Dries rather slowly as an oil paint, forming a fairly strong film.

Chrome Yellow Lemon

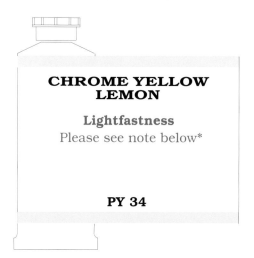

CHROME YELLOW LEMON

Lightfastness
Please see note below*

PY 34

Orange-yellows are available under this name but the colour usually leans towards green. For this reason it is often described as a Lemon Yellow.

Reasonably strong with good covering power.

* PY34 Chrome Lemon Yellow has been given a lightfast rating of 1 Excellent, by the ASTM .

This would suggest that the colour will be permanent in all media as watercolours are the most susceptible to damage from exposure to light.

However, it is possible that the testing was carried out using one of the new encapsulated varieties of the pigment.

Certain manufacturers are describing this pigment as being lightfast (according to ASTM test results), when they are not, in fact, using one of the recent encapsulated varieties.

As with other Chrome Yellows, this pigment has a very poor reputation. There have been many reports of it darkening after exposure to light and the Hydrogen Sulphide of the atmosphere.

Every example, in all media that I have personally tested has failed, and failed convincingly.

As this colour does not bring any special advantage to the artists' palette, and has a very poor reputation, it is difficult to see why it is still around- perhaps because it can be sold to the unwary.

Use with caution if you find it irresistible.

Personally I would leave it well alone, it is an unnecessary colour easily matched.

Why take the chance of spoiling your work? There are alternative, reliable green-yellows on the market.

For reasons of their own, some paint manufacturers produce this colour using reliable green-yellow pigments such as PY3 Arylide Yellow. They then market the colour as 'Chrome Yellow Lemon'.

A reliable pigment sold under an unreliable name. It all adds to the confusion that they have collectively brought about.

Not recommended

unless you are certain of the pigment used.

Mixing tips

If you have this colour in your paint box I suggest that you only use it for practice purposes.

Being a green-yellow it will give very similar results to those obtained when working with either Arylide (Hansa) Yellow Light page 23) or Cadmium Yellow Lemon (page 28).

If you have already used this colour in your work, it is best kept in subdued light and behind glass to protect it from the atmosphere.

Technical information: *Common Name* - Chrome Yellow Lemon. *Colour Index Name* - PY34. *Colour Index Number* 77600. *Chemical Class* - Lead chromate and lead sulphate. *ASTM Lightfast rating* - In watercolours I: Excellent (Please see note above*). *Transparency* - Semi -Transparent.

Chrome Yellow (Light, Medium & Deep)

CHROME YELLOW
(Light, Medium & Deep)

Lightfastness

Not yet tested by the ASTM but has a very poor reputation in all media.

PY 34

Fairly strong with good covering power.

This colour has been available to artists for some time and seems to have acquired a 'traditional' value, some manufacturers telling us that this or that famous artist of the past used it.

What they do not tell us is that those same artists would almost certainly have used modern alternatives if they were available.

On the other hand of course, they might well have used chrome yellow out of ignorance, as so many professional artists still do.

Do not be taken in by the hype, the Chrome Yellows (with the possible exception of certain modern Chrome Yellow Lemons) have long been known to cause damage to paintings. Exposure to light and the atmosphere leads to quite rapid change.

It becomes dark and dull as an oil colour and usually fades and moves towards green or brown when made into a watercolour paint.

Some manufacturers actually sell reliable alternative pigments under this name. Do not encourage this practice with your hard earned money, it can only prolong the confusion.

To my mind Chrome Yellow is a quite worthless colour, far inferior to Cadmium and certain Arylide yellows. I would not even consider its use.

Not recommended

Chrome Yellows were used by Vincent van Gogh in his painting 'Sunflowers'.

Mixing tips

Although they would have started as bright as any modern Chrome Yellow they have all become relatively dull and brownish.

This is tragic considering the intensity of his feelings towards colour.

I would suggest that you do not allow your own work to suffer in this way. If you have purchased any of the Chrome Yellows in the past I would recommend that you use them only for temporary work.

Low in cost, but a false economy if you place any value on your creative effort.

Sometimes leaning towards green but more often towards orange. Mix accordingly if you decide not to help this colour to become obsolete.

Please bear in mind that the Chrome Yellows will not only deteriorate when applied unmixed but will also spoil any other colour with which they are blended.

Illustration: Sunflowers by Vincent van Gogh. Courtesy the National Gallery, London.

Technical information: *Common Name* - Chrome Yellow Lemon. *Colour Index Name* - PY35. *Colour Index Number* 77600 & 77603. *Chemical Class* - Lead Chromate and Lead Sulphate. *ASTM Lightfast rating* - Not yet tested in any media. Has a very poor reputation for reliability. *Transparency* - Opaque. *Drying* -Dries fairly quickly as an oil paint. Low to average oil content.

Gamboge

GAMBOGE

Lightfastness

This pigment has not yet been tested by the ASTM.
As a watercolour it has a very poor reputation and failed our own testing.

NY 24

The tree sap from which genuine Gamboge is produced is often collected in short lengths of bamboo, which act as moulds.

Genuine Gamboge is produced from the resin of a tree found in various parts of Asia. It would be better to leave the tree alone as the colour is particularly fugitive.

Of use only as a watercolour paint in its pure form. The actual colour offered in watercolours and other media is usually a combination of pigments which more or less resemble the original Gamboge.

These can be reliable, but seldom are.

As we are faced with a rather motley collection of 'Gamboges', produced from all manner of yellows, with the addition of various reds, we have to ask ourselves just why this situation exists.

Is it because certain manufacturers wish to off-load cheap and inferior pigments, or because artists have to be offered an excessively wide range of pre - mixed colours as too few can mix their own with confidence?

Look out for the use of cheap, worthless industrial pigments such as PY1 Arylide Yellow and PR3 Toluidine Red. They are a favourite combination and produce an orange-yellow which will quickly fade.

To add to this confusing situation there are reliable mixes amongst those on offer. Check the ingredients very carefully before making a purchase.

In whatever form, Gamboge is an unimportant colour easily duplicated on the palette.

Ignore any hype about genuine Gamboge being a *traditional watercolour paint.*

It is, and always has been, quite worthless to the artist. A fact known full well by manufacturers of the colour.

Not recommended

unless suitable
pigments have been used.

The genuine article fades very quickly despite 'tradition' and the romance of the name,

Mixing tips

Cadmium Yellow Light with a touch of Cadmium Red Light will easily match most 'Gamboges' on offer. They will not give an orange yellow as transparent as genuine gamboge but will outclass the usual mixes on offer.

If you do decide to use genuine gamboge you will find that it can be very difficult to handle when at all heavy.

As a thin wash it brushes out smoothly. That's about all I want to say on this colour. It has become little more than a name to sell an additional pre-mix paint.

Technical information: *Common Name* - Gamboge. *Colour Index Name* - NY24 (Natural yellow 24). *Colour Index Number* - NA . *Chemical Class* - NA. *ASTM Lightfast rating* - Not yet tested. *Transparency* - Transparent. *Staining power* - Slight.

Indian Yellow

INDIAN YELLOW

Lightfastness

This is impossible to give as a wide variety of pigments are employed.

The Colour Index name varies

There will be differences, throughout the book, between the colour sample (as shown above) and the colour bands on the tube (as at right). This is becasue I have tried to give the 'average' colour on the tube and have shown one of the varieties on the colour sample.

As the name suggests, this colour had its origins in India. Cows were fed a diet of mango leaves and then denied water. Their concentrated urine was collected and mixed with mud. This was later purified into a very clear bright yellow.

This is yet another name from the past used to sell a variety of pre-mixed yellows.

These vary from reliable mixtures to yellows which will fade rapidly. By now you are probably wondering why so many mixtures (of varying reliability) are offered under what are suggested as standard colour names.

Without a doubt, most manufacturers feel left out if they do not offer a vast range. But the main contributing factor must be that the majority of artists do not feel confident in using just two or three yellows and blending further.

If you have become used to a certain 'Indian Yellow', in whatever media, I would suggest that you check the ingredients before further use.

On page 37 you will find a lists of recommended pigments. This, plus the information given below, will help you to select reliable versions of this colour.

Not recommended

unless suitable pigments have been used.

Suitable pigments.

Which might be found in the make up of this colour.

PY154
Benzimidazolone Yellow
H3G.
PY43 Yellow Ochre
PY153
Nickel Dioxine Yellow
PY3
Arylide Yellow
PO 43
(Pigment Orange 43)
Perinone Orange

Borderline pigments.

Certain varieties of the following can be prone to fading (especially when made up into watercolour or gouache paints).
I suggest that you either avoid them in water based media or treat them with extreme caution.

PY83 HR70
Diarylide Yellow HR70

PY1:1
Arylide Yellow

Unsuitable pigments.

Found in certain 'Indian Yellows', the following are known by manufacturers to be unsuitable for inclusion in artists' paints.

PY1
Arylide Yellow
PY17
Diarylide Yellow AO
PY100
Tartrazine Lake

Technical information: *Common Name* - Indian Yellow. As the ingredients vary widely and an accepted make up is not followed, it is not possible to give details of pigments used, lightfastness or staining power.

Mars Yellow

MARS YELLOW

Lightfastness
Watercolours I: Excellent
Oils I: Excellent
Acrylics I: Excellent
Gouache I: Excellent
Alkyds I: Excellent

PY 42

Mars Yellow can be considered to be a synthetic version of Yellow Ochre, a naturally occurring pigment.

Strangely enough, Yellow Ochre (PY43) is often sold as Mars Yellow (PY42), and the other way round. At one time the only watercolour paint that I could find described as Mars Yellow was actually Yellow Ochre. Who said that many manufacturers cause unnecessary confusion?

Mars Yellow is more commonly found as an oil paint or an acrylic.

A neutralised (dulled) orange-yellow. When well made it has good tinting strength and covers well. Often slightly brighter and stronger than Yellow Ochre. It is also usually more transparent due to the absence of clay.

This is an excellent colour, absolutely lightfast and compatible with all other colours.

Unless the subtle differences are vital to your work I would suggest that you choose between this colour and Yellow Ochre.

For most purposes, to purchase both would be an unnecessary extravagance, particularly when, as with most hues, it will probably be modified through mixing, which will quickly disguise any real differences.

Recommended

Mixing tips

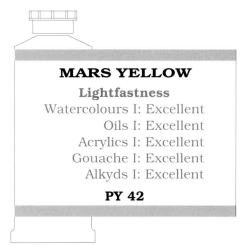

As with any paint, when the 'colour type' is described

correctly it will become more versatile when mixing.

Being a neutralised (dulled) orange-yellow means that it will lead towards dull greens (an orange-yellow 'carries' very little green) and will give brighter oranges with an orange-red. These will still be subdued as the reason that the colour is a *dulled* orange-yellow is because it does not reflect a great deal of either colour.

Will give soft, dulled greens with Cerulean Blue (a green-blue)

and brighter, but still subdued oranges with Cadmium Red Light (orange-red).

Technical information: *Common Name* - Mars Yellow. *Colour Index Name* - PY42. *Colour Index Number* - 77492. *Chemical Class* - Synthetic Hydrated Iron Oxide. *ASTM Lightfast rating* - In all media I: Excellent. *Transparency* Semi-Opaque to Opaque. *Drying* - An average drier as an oil paint, forming a fairly strong film. Medium to high oil content.

Naples Yellow

NAPLES YELLOW

Lightfastness

Watercolours I: Excellent

Oils I: Excellent

Acrylics I: Excellent

Gouache I: Excellent

PY37 not yet tested in Alkyds but should prove
to be equally lightfast.

PY 35 or PY 37 plus a white

I have described the colours covered so far by their Common Name and pigment.

In the case of Naples Yellow I will concentrate on the pigments used and sold under this name.

Genuine Naples Yellow, (PY41) is a lead - based pigment rarely used nowadays,

You might occasionally come across its use as an oil paint. It is particularly lightfast with an ASTM rating of I.

The name is now generally used to describe a blend of Cadmium Yellow and white. Small amounts of red and yellow ochres might be added to modify the colour.

Where such pigments have been used the colour is reliable, but do check.

If the paint label does not clearly state that either Cadmium Yellow Light (PY35) or Medium (PY37) plus white has been used, the paint is best

left in the paint rack.

Where other yellows have been used, for 'alternative' usually read 'cheaper' and 'inferior'. If alternative yellows have been employed check the ingredients with this book.

If the ingredients are not actually given on the label do not even consider a purchase.

A smooth, opaque colour which should handle well.

Recommended

Naples Yellow is a convenience colour rather than a unique hue as it is easily blended on the palette. But it does have its uses and is a popular blend.

When mixing, treat as a neutralised (or dulled) pale orange - yellow.

The white in the colour will soften and dull other colours in a mix. *Who said that watercolourists do not use white in their work?*

Mixing tips

It will give soft, subtle, opaque greens with Cerulean Blue -

and dulled neutral oranges with Cadmium Red Light. There are many other uses.

Technical information: *Common Name for the blended colour* - Naples Yellow. *Colour Index Name* PY35 or PY37 plus a white. *ASTM Lightfast rating for this combination* - I: Excellent. *Transparency* - Opaque. *Staining power* - Slight. *Common Name for the genuine pigment* - Naples Yellow. *Colour Index Name* - PY41. *Colour Index No.* - 77589. *ASTM Lightfast rating* I: Excellent. *Transparency* - Opaque. *Drying* - Average drier as an oil paint, forming a strong film. Average oil content.

Yellow Ochre

YELLOW OCHRE

Lightfastness
Watercolours I: Excellent
Oils I: Excellent
Acrylics I: Excellent
Gouache I: Excellent
Alkyds I: Excellent
PY 43

Pigment Yellow 43, Yellow Ochre, has been in constant use since the days of the cave painter, although they probably had a different name for it.

It is absolutely lightfast. The many examples of coloured earths in the landscape are proof that pigments produced from them do not fade under the harshest of light and weather conditions, over endless years. Yellow Ochre is a carefully selected and processed natural coloured earth.

A soft, dulled golden yellow which brushes and mixes well over a full range of values. The better grades can be fairly transparent in thin washes but will cover well when applied at all heavily.

Tinting strength varies but is usually strong enough to play its part in colour mixing.

Considered by many artists to be a softer, less brash colour than its artificial counterpart, Mars Yellow.

You will come across many examples of Mars Yellow (PY42) on sale as Yellow Ochre, and Yellow Ochre (PY43) being offered as Mars Yellow.

In fact, the majority of 'Yellow Ochre' watercolours on the market are produced using Mars Yellow. Makes you wonder what its all about, doesn't it? Could Mars Yellow pigment be any cheaper than a well produced Yellow Ochre?

Check ingredients if you wish to select the characteristics of one over the other.

Recommended

For mixing purposes treat as a low intensity, neutralised, opaque orange-yellow.

Mixing tips

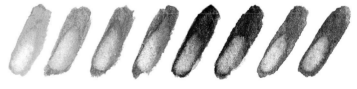

It will therefore behave in a similar way to Naples Yellow and Mars Yellow.

The mixing complementary is violet-blue. These two colours will darken each other without destroying the character of either, as black certainly would.

They will also produce some very subtle greys when mixed in near equal intensities, particularly when these are made lighter.

Technical information: *Common Name* - Yellow Ochre. *Colour Index Name* - PY43. *Colour Index Number* - 77492. *Chemical Class* - Natural Hydrated Iron Oxide. *ASTM Lightfast rating* - In all media I: Excellent. *Transparency* Semi-Opaque but reasonably transparent in thin applications. *Staining power* - Slight. *Drying* - Dries medium to slowly forming a fairly strong film as an oil paint. Medium oil content.

Miscellaneous yellows

Stil de Grain is a meaningless name from the past, used to sell a variety of greenish yellows of varying pedigree.

Aurora Yellow is used to sell PY37 Cadmium Yellow Light, a pigment which I feel should be sold only under its own name.

Green Pink. Pink was at one time the noun for yellow. The name no longer has any meaning and will not have any bearing on the pigments used.

Permanent Yellow is used to describe yellows which are actually lightfast as well as those which will fade dramatically. What's in a name?

Brilliant Yellow, sometimes is and sometimes isn't. Sometimes fades and sometimes doesn't.

Greenish Yellow, Golden Yellow, Deep Yellow, Light Yellow. Such names describe hues which are easily blended on the palette, using reliable ingredients.

Helio Yellow, Helios Yellow, Juane Brilliant, Sahara Yellow, Sunny Yellow, Yellow Lake, and the list goes on. Always check the pigments before making a purchase. Please see next page for pigments list.

Lurking behind the name **Azo Yellow** you will often find the notoriously unreliable PY1 Arylide Yellow G.

Gallstone, yet another meaningless name from the past, used to sell a variety of pigments

There are a wide variety of yellows on the market which have been given fancy or trade names: Aurora Yellow, Blockx Yellow, Brilliant Yellow, Flanders Yellow - to mention just a few.

These vary from superb, lightfast colours to those which will fade rapidly. Of 46 watercolours sold under such names as the above, 25 were either borderline or quite unsuitable for artistic use.

As there is a good range of well tested and reliable yellows, one wonders at the need for additional examples.

Trade names are perhaps understandable for commercial reasons but this does not necessarily give credibility, as more than one company is prepared to offer fugitive colours under its name.

Whatever the reason, you should be aware that this is often a dumping ground for cheap and unreliable industrial colours.

PY1 Arylide Yellow G, a particularly inferior pigment, finds its way into many a miscellaneous yellow. Manufacturers know full well that it has failed every test, and failed dismally.

So, it quickly fades away in all media, spoiling any work on which it has been used. Who cares? At the end of the day only you, I and a tiny minority of colormen really care.

If you find a reliable pigment such as PY35 Cadmium Light sold under a fancy name ask yourself if you really need it. You might already have the identical colour or could easily match it with a little mixing. Be wary of the market place.

Yellow pigments to choose or avoid

The following pigments have not all been subjected to ASTM testing. Where they have not, I am offering guidance based on other independent testing as well as my own. The text in colour relates to the same pigment appearing in two different lists. For example, PY 74 LF (in red) is in the following list of reliable pigments and also appears over the page on the list of pigments liable to fade as a watercolour.

Reliable pigments - all have been subjected to vigorous testing.

PY3 Arylide Yellow 10G - tested in all media.

PY31 Barium Chromate Lemon - tested I: Excellent, as a watercolour.

PY35 Cadmium Yellow Light - tested I: Excellent, in nearly all media.

PY35:1 Cadmium-Barium Yellow Light - tested in nearly all media. Rated I: Excellent.

PY37 Cadmium Yellow Medium or Deep - tested in nearly all media. Rated I: Excellent.

PY37:1 Cadmium-Barium Yellow Medium or Deep - tested in oils & acrylics. Rated I: Excellent.

PY40 Aureolin - tested II: Very good, in oils and watercolour.

PY41 Naples Yellow (genuine) - tested I: Excellent in oils.

PY42 Mars Yellow or Yellow Oxide - tested I: Excellent in all media.

PY43 Yellow Ochre - tested I: Excellent in all media.

PY53 Nickel Titanate Yellow - tested I: Excellent in oils, acrylics and gouache. A weak green-yellow.

PY65 Arylide Yellow RN - tested I: Excellent, in oils and acrylics.

PY73 Arylide Yellow GX (Hansa Yel. GX) - tested I: Excellent, in oils and acrylics.

PY74LF Arylide Yellow 5GX - tested I: Excellent, in oils & acrylics, and II: Very Good, in gouache. (Poor as a w/col please see notes, next page).

PY83 HR70 - tested I: Excellent in oils and acrylics. (Good to poor as a watercolour).

PY97 Arylide Yellow FGL -tested II: Very Good, in watercolours, indicates is reliable in all media.

PY98 Arylide Yellow 10GX (Hansa Yel. 10GX) - tested well in oils and acrylics.

PY108 Anthrapyrimidine Yellow - tested well as an oil and acrylic.

PY109 Isoindolinone Yellow G - tested I: Excellent, in oils, acrylics & gouache. Not tested other media.

PY110 Isoindolinone Yellow R - tested I: Excellent, in oils, acrylics and gouache. (Poor in watercolour).

PY112 Flavanthrone Yellow - tested I: Excellent, in oils and acrylics. Not yet tested in other media.

PY 119 Zinc Iron Yellow - tested II in own tests.

PY129 Azo-Methine Yellow - only tested in alkyds, rated I: Excellent.

PY138 Quinophthalone Yellow - tested I: Excellent in oils and acrylics.

PY139 Isoindoline Yellow - tested I: Excellent, in oils, acrylics and gouache.

PY150 Nickel Azo Yellow - tested I: Excellent, in oils and acrylics.

PY151 Benzimidazolone Yellow H4G - tested I: Excellent, in oils and acrylics.

PY153 Nickel Dioxine Yellow - tested I: in oils and acrylics.

PY154 Benzimidazolone Yellow H3G - tested I: in oils and acrylics.

PY170 Diarylide Yellow - only tested in gouache.

PY175 Benzimidazolone Yellow H6G - tested I: in oils and acrylics.

PY177 Irgazin Yellow 4GT - own testing only, found to be reliable.

Suitable in certain media but will tend to fade as a watercolour and/or a gouache.

PY4 Arylide Yellow 13G

PY74LF Arylide Yellow 5GX - tested well in other media (see above), but poorly in w/col.

PY83 HR70 - tested well in oils/acrylics (see above), not tested in w/colour but my testing gave varying results, from reliable to poor. Possibly variations in manufacture. Use caution in watercolour.

PY110 Isoindolinone Yellow R - tested well in other media (see above), but poor as a w/col.

Most unsuitable for artistic use - poor to very poor lightfastness.

PY1 Arylide Yellow G - particularly poor as a watercolour paint or gouache.

PY1:1 Arylide Yellow G

PY12 Diarylide Yellow AAA - own testing, has a poor reputation.

PY13 Diarylide Yellow AAMX - own testing.

PY14 Diarylide Yellow OT - own testing.

PY17 Diarylide Yellow AO - own testing.

PY20 Benzidine Yellow B - own testing.

NY24 Gamboge - own testing.

PY34 Chrome Yellow Lemon - (perhaps not the new encapsulated version).

PY55 Diarylide Yellow PT - tested in gouache as V: Very poor (fugitive)

PY100 Tartrazine Lake - totally failed testing as a watercolour.

Introduction to oranges

Helene Rouart in her Father's Study, by Hilaire-Germain-Edgar Degas. Courtesy The National Gallery, London.

A Young Woman standing at a Virginal by Johannes Vermeer. Courtesy The National Gallery, London.

The combination of orange and blue, visual complementaries, has been put to widespread use throughout the world and throughout history.

Without a doubt, the most popular colour arrangement, spanning all ages and virtually all countries, has been blue and orange. The oranges employed have varied from dull earth colours to bright, fluorescent hues.

As I have mentioned elsewhere, artists of the past suffered many limitations in their materials. As an example of this, from ancient times to the late 19th century they had at their disposal an arsenic - based orange pigment, Realgar.

The main drawback to the use of this colour was that it often either killed the user or made them very sick, and that's some drawback.

Realgar was replaced by Cadmium Orange, a superb pigment with many fine qualities.

As you will see, Cadmium, Benzimidazolone and Perinone are the only oranges really worth considering, and then only if you wish to exploit their colour without any modification through mixing.

Virtually all other oranges on the market are either easily duplicated on the palette, using reliable contributing colours, or they are pre-mixed by the manufacturer from pigments known to be inferior.

Benzimidazolone Orange H5G

BENZIMIDAZOLONE ORANGE H5G

Lightfastness
Watercolours I: Excellent
Oils I: Excellent
Acrylics I: Excellent
Not yet tested in alkyds or gouache but should prove to be equally lightfast.

PO 62

If you prefer to purchase your orange rather than mix it, then this will be a particularly good buy. A fairly strong, reasonably bright mid orange.

Although semi-opaque, it does have the strength to enable quite thin applications.

A reliable orange which has proved to be lightfast and was given an ASTM rating of 1 as a watercolour.

Where a watercolour is shown to be lightfast we can be sure that the pigment will perform well in other media, where the binder offers greater protection.

There are colours which prove to be lightfast, say as an oil paint, but without the added protection of the binder, will fail as a watercolour paint.

You might also come across Benzimidazolone Orange HL, PO36. This is another reli-able, semi-opaque orange. It leans more towards red.

I am very aware that colour descriptions such as Benzimidazolone are anathema to many artists. But it is surely better to come to terms with the correct descriptions rather than be led towards colours which will fade or darken. Both versions of this colour are:

Recommended

When considering the mixing potential of any colour it is essential to describe the colour type to yourself first.

With an orange, for example, you should decide whether it is a yellow, red or mid-orange and choose the mixing partner or partners accordingly. The transparency should then be taken into account.

This is a straight forward colour to work with, being a mid, semi-opaque orange.

As with any orange, it darkens beautifully with blue.

Mixing tips

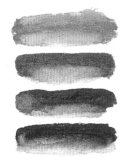

Add Ultramarine Blue for a range of darkened oranges which will stay close to their original character.

Or Cerulean Blue for oranges which will darken and move towards dull greens.

Technical information: *Common Name* - Benzimidazolone Orange H5G. *Colour Index Name* - PO 62. *Colour Index Number* - 11775. *Chemical Class* - Benzimidazolone derived pigment Monoazo: Acetoacetyl. *ASTM Lightfast rating* - In oils, watercolour & acrylics I: Excellent. *Transparency* - Semi-opaque.

Cadmium Orange

CADMIUM ORANGE
Lightfastness
Watercolours I: Excellent
Oils I: Excellent
Acrylics I: Excellent
Gouache I: Excellent
Alkyds I: Excellent

PO 20

The range varies from a yellow to a very red orange. Cadmium Orange Light, Deep and Red are available. 'Cadmium Orange Azo' usually contains the inferior PY1 or PO13.

A well made Cadmium Orange is intense, bright, fairly strong, and very opaque,

Its strength will enable efficient covering of other colours and at the same time allow reasonably clear layers when applied thinly.

You should be aware that there are many imitations on the market described as Cadmium Orange.

Unfortunately the word 'Hue', which will identify an imitation, is not always used.

Genuine Cadmium Orange is lightfast - many of the imitations are not.

Look out for the use of pigments such as PY1 Arylide Yellow, PR4 Chlorinated Para Red and PO13 Pyrazolone Orange. All have failed ASTM lightfast tests, and failed them dramatically.

Manufacturers using such pigments and passing them off as Cadmium Orange show only contempt for the artist. They are fully aware that the colours will deteriorate rapidly, spoiling the work.

Cadmium Barium Orange PO 20:1 is also lightfast but not always quite so bright.

Look for the genuine ingredients, make sure that the brightness has not been dimmed with filler and you will not go far wrong.

Recommended

Mixing tips

Will darken well with the appropriate blue, depending on whether the version you choose leans towards yellow or red.

If it leans strongly towards yellow, use Ultramarine Blue, a violet-blue. If your selection leans towards red use a green blue such as Cerulean.

A little experimentation will quickly show which blue will darken the orange as well as keep it in character.

As the Cadmiums are all part of the same 'family' they will intermix beautifully. Add any of the Cadmium yellows or reds to move the orange in either direction. The widest range will come from using Cadmium Yellow Light and Cadmium Red Light. In fact these two colours will give an orange identical to most Cadmium Oranges.

Technical information: *Common Name* - Cadmium Orange. *Colour Index Name* - PO 20. *Colour Index Number* - 77202. *Chemical Class* - Concentrated Cadmium Sulfo-selenide *ASTM Lightfast rating* - In all media I: Excellent. *Transparency* - Opaque but reasonably transparent in thin applications. *Staining power* - Slight. *Drying* -Dries very slowly to a fairly strong film as an oil paint.

Chrome Orange

CHROME ORANGE

Lightfastness
Please see notes below.

PR 104

The colour varies from a yellow to a red-orange.

I find this colour is rather difficult to advise on.

PR 104, Chrome Orange, tested ASTM I: Excellent as a watercolour.

It could be, however, that one of the newer encapsulated varieties was involved, as every paint made up with this pigment that I have ever tested, has darkened on exposure to light.

There would seem to be some confusion surrounding this pigment. The test results have encouraged manufacturers to claim a rating of ASTM whether or not they are using a reliable version.

I have certainly found Chrome Oranges, produced from PR 104, (and described as lightfast), which darkened very quickly on exposure.

Unless you are a gambler, why risk your work. A colour which starts off as a bright orange and later turns into a dull orange brown will quickly alter the nature of a painting.

Chrome Orange can be PR 104, a mix of Chrome Yellow Lemon and Chrome Orange or a mix of almost anything.

Personally I would avoid all colours sold under this name which contained either PR 104 Chrome Orange or PY 34 Chrome Yellow Lemon.

Far too many unreliable versions of these pigments are on the market.

To add to the confusion, a variety of other yellows and reds are also mixed and sold under this name. Most are produced from cheap industrial colorants which will deteriorate rapidly.

I find it incredible that reliable pigments such as Benzimidazolone Orange H5G are also marketed under this name - a name from the past which is synonymous with unreliability.

Why do so many manufacturers continue with and even add to, the confusion? They seem to love it.

Perhaps it is because the muddle of names and information allows all manner of inferior substances to be sold.

The sad thing is, they are sold alongside some of the finest colours which have ever been available to the artist.

I realise that I will probably come under fire for suggesting the avoidance of a colour which has received a high ASTM lightfast rating, but other factors are also involved.

Not Recommended

Technical information: *Common Name* - Chrome Orange. *Colour Index Name* - PR 104. *Colour Index Number* - 77605. *Chemical Class* - Lead Chromate and Lead Molybdate *ASTM Lightfast rating* - In watercolours, I: Excellent. Please see notes above. *Drying* - Very quick drier as an oil paint.

Perinone Orange

PERINONE ORANGE

Lightfastness
Oils I: Excellent
Acrylics I: Excellent
Gouache I: Excellent

PO 43

Most prepared oranges are superfluous, as a mix of good quality Cadmium Yellow Light and Cadmium Red Light will give a range of bright, lightfast oranges hard to surpass.

Such oranges are opaque, following the nature of the yellow and red.

Because bright, strong *opaque* oranges are easily mixed, it could be said that there is little point in pur-chasing Cadmium Orange, which is equally *opaque* (page 41). Or Benzimidazolone Orange H5G, a *semi-opaque* colour, (page 40).

However, if you need a reasonably *transparent* colour, then Perinone Orange might be of value to you. Perinone Orange has proved to be totally reliable when made into either an oil paint or an acrylic. In our own tests, as a watercolour, it stood up to light extremely well. This is a very commonly used pigment.

Unfortunately it is often sold under names such as 'Brilliant Orange'. One day perhaps it will be realised that artists can cope with names of over two syllables.

Recommended

Mixing tips

Varies in colour from a mid orange to a red-orange. If using the complementary to darken the colour, experiment with various blues first.

The ideal is to select a blue which will keep the orange in character as it darkens.

This way you will obtain the maximum control over the mixes and will be better able to forecast the results.

Perinone Orange,
Semi-transparent.

Benzimidazolone Orange
H5G. Semi-Opaque.

Cadmium Orange.
Opaque

Cadmium Red Light and
Cadmium Yellow Light mix.
Opaque.

Transparency can be the deciding factor when selecting a prepared orange.

Technical information: *Common Name* - Perinone Orange. *Colour Index Name* - PO 43. *Colour Index Number* - 71105. *Chemical Class* - Perinone. *ASTM Lightfast rating* - In oils, gouache and acrylic, I: Excellent. Own testing as a watercolour II: Very Good. *Transparency* - Semi-Transparent to transparent.

Miscellaneous oranges

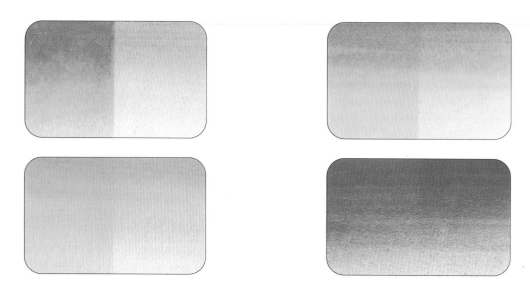

The above colours are all on offer as Artists Quality paints, in all media. The samples shown were subjected to the amount of indirect light falling on an interior wall over 1-2 years. It is not difficult to imagine the speed with which such colours will destroy a carefully executed piece of work. Apart from the profit that can be made from supplying such materials, there is absolutely no reason whatsoever for fugitive orange paints, in any media, to be offered to the artist.

Apart from Cadmium, Benzimidazolone and Perinone Orange, there is very little else on the market to be recommended.

Most oranges are ready mixed from various reds and yellows. One or two might be worth considering if you are absolutely certain of the pigments used.

All manner of names are in use: Brilliant Orange (which sometimes is), Permanent Orange, Helio Orange, Chinese Orange, Mars Orange, Azo Orange etc.

If the pigments in a particular orange are simply described as being AZO or AZOIC put the tube back on the rack as the term is quite meaningless.

Look out for names such as 'Permanent Orange' some employ lightfast pigments, others are anything but permanent.

Do not be lulled into a false sense of security by oranges sold under a company name: 'Smiths Orange' etc. More than one manufacturer is prepared to sell colours, which they know will deteriorate rapidly, under their own name.

Be wary of mixed oranges containing any of the following pigments: PO 1 Hansa Orange, PO 13 Pyrazolone Orange, PO 34 Diarylide Orange, PR 104 Chrome Orange, PY 34 Chrome Yellow Lemon, PY 20 Benzidine Yellow, PR 83:1 Alizarin Crimson, PR 105 Red Lead.

If it sounds as though I am warning about the widespread use of inferior pigments where their use can best be disguised (in a mixed colour), it is because I am.

The level of fugitive mixed oranges on sale in all media is quite outrageous.

Orange pigments to choose or avoid

The following pigments have not all been subjected to ASTM testing. Where they have not, I am offering guidance based on other independent testing as well as my own.

Reliable pigments, all have been subjected to vigorous testing.

PO5 Dinitraniline Orange - tested II: Very good in acrylics & oils, I: Excellent, in gouache.

PO20 Cadmium Orange - tested I: Excellent, in all media.

PO20:1 Cadmium-Barium Orange - tested I: Excellent, in acrylics & oils.

PO23 Cadmium Vermillion Orange - tested I: Excellent, in acrylics & oils.

PO23:1 Cadmium-Barium Vermillion Orange - tested I: Excellent, in acrylics & oils.

PO36 Benzimidazolone Orange HL - tested I: Excellent, in acrylics & oils.

PO43 Perinone Orange - tested I: Excellent, in acrylics, oils & gouache.

PO48 Quinacridone Gold - tested I: Excellent, in acrylics & oils.

PO49 Quinacridone Deep Gold - tested I: Excellent, in acrylics & oils.

PO60 Benzimidazolone Orange - tested I: Excellent, in acrylics & oils.

PO62 Benzimidazolone Orange - tested I: Excellent in watercolour, acrylics and oils.

Most unsuitable for artistic use, having poor to very poor lightfastness.

PO1 Hansa Orange - failed our own testing and has a poor reputation.

PO13 Pyrazolone Orange - failed our own testing plus ASTM result of V (fugitive) in Gouache.

PO34 Diarylide Orange - failed our own testing as a watercolour.

PR104 Chrome Orange - failed our own testing as a watercolour. See page 42 for further information.

Introduction to reds

A wide range of red substances occur in nature and have been adapted for the needs of the artist. Various flowers, woods, insects, roots and coloured clays have provided us with reds varying from reliable to disastrous.

Over the centuries the range of red pigments and dyes has been constantly refined and expanded, with many of the original natural reds being made synthetically. It has been a story of constant change with one red or group of reds, replacing another.

To follow one such sequence of change, one of the earliest red pigments was Cinnabar, produced from a hard rock. A synthetic version of Cinnabar, Vermilion was then developed. Vermilion, which has certain limitations, has now all but been replaced by Cadmium Red Light.

As another example, various vegetable and insect based reds were earlier replaced by a violet-red produced from the root of the madder plant. One of the colorants extracted from the root, Alizarin, was later produced synthetically. Unfortunately it is still with us.

Although we have superb alternatives, Alizarin Crimson is still in widespread use and continues to destroy one painting after another.

It has been known for decades that Alizarin will fade as a thin wash or when mixed with white, yet manufacturers still continue to market it. It is not only sold under its own name but finds its way into many other colours under a variety of descriptions.

For reasons best known to themselves, art writers and teachers continue to promote this worthless substance, in the face of the superior violet-reds which are available today.

The process of change continues, but should be hurried along, as we still retain far too many of the inferior reds from the past.

There are a tremendous number of red pigments in use today, unfortunately a high percentage are entirely unsuitable for artistic use. This situation is balanced by the fact that we have reds which earlier artists would have given almost anything to obtain.

The wise buyer will always check the pigments used in a particular colour and select accordingly. Change will only come about when forced on the manufacturer by the buyer.

Alizarin Crimson

Alizarin Crimson is to be found in a very wide range of colours, sold under its own name as well as many others. It also plays a big part as an additive in such colours as 'Rose Madder', 'Madder Lake' and 'Brown Madder'.

Alizarin Crimson is the standard violet-red of the majority of artists and found in many of their colours. A material in very widespread use which finds its way onto many a painting.

In view of the above one would expect it to be suitable for artistic work. It is not. All manufacturers offering this colour are fully aware that it has failed all lightfast tests to which it has been subjected.

As a thin wash or when reduced with white it fades at a steady pace.

When applied thickly it resists fading but takes on a very dark appearance. It is also prone to cracking in heavy applications.

So why is it still in widespread use when there are superior violet reds such as the superb Quinacridone Vio-let available? It is all to do with what can be sold to the unwary and where the main profit lies.

Help to make this an obsolete colour. It has no place on the modern palette.

Recent versions offered under such names as 'Crimson Alizarin Permanent' are invariably based on the reliable Quinacridone Violet PV 19 (page 52).

Why keep up the confusion when this colour is also sold under its own name.

Not Recommended

Mixing tips

One of the main tasks of a violet-red is to provide bright violets when mixed with a violet-blue.

A mix of Alizarin Crimson and Ultramarine Blue will always be much duller than a violet produced from Quinacridone Violet and Ultramarine.

When applied at all thinly the former mix will become bluer as the red content fades.

*Alizarin Crimson and
Ultramarine Blue.*

*Quinacridone Violet and
Ultramarine Blue.*

If you are used to Alizarin Crimson and wish to mix a similar but lightfast version, dull Quinacridone Violet with a little Viridian or Phthalo Green. A touch of Burnt Sienna to this mix will duplicate the colour exactly.

Technical information: *Common Name* - Alizarin Crimson. *Colour Index Name* - PR 83:1. *Colour Index Number* - 58000:1. *Chemical Class* - 1,2 Dinydroxy Anthraquinone. *ASTM Lightfast rating* - In watercolour IV: Will fade rapidly. Failed in other media testing. *Transparency* - Transparent. *Staining power* - High staining. *Drying* - Dries slowly to a rather soft film as an oil paint. The oil content is rather high.

Cadmium Red Light

CADMIUM RED LIGHT

Lightfastness
Watercolours I: Excellent
Oils I: Excellent
Acrylics I: Excellent
Gouache I: Excellent
Alkyds I: Excellent

PR 108

A good quality Cadmium Red Light can be rather expensive, but it will be money well spent.

Bright, strong, opaque and absolutely lightfast, it is a superb colour.

When well produced the paint handles very positively in all media, giving smooth, even layers and washes.

An opaque colour which covers well and has the added strength to allow reasonably thin layers and washes.

To my mind this is the ideal orange-red and it will be worth taking extra time to choose a suitable version.

If possible, try various makes held by fellow artists or quietly unscrew the paint caps in your art store to check for brightness.

Cadmium Red Light has largely replaced Vermilion, an orange-red with a troubled history.

A superb all round orange-red, but the same can-

not be said for imitations. Apart from the rare exception I would avoid all student quality versions.

These can normally be identified by the use of the word 'Hue' or 'Azo' following the name.

More than one Artists' quality 'Cadmium Red' on the market has not been near Cadmium Red pigment, so check the pigments carefully before making a purchase.

Recommended

Cadmium Barium Red PR 108:1 is usually slightly weaker and should be less expensive.

Mixing tips

Being an orange-red it darkens beautifully with the complementary blue-green.

In these examples the blue-

green has been mixed from Cerulean Blue and Arylide Yellow 10G.

Technical information: *Common Name* - Cadmium Red Light. *Colour Index Name* - PR108. *Colour Index Number* 77202. *Chemical Class* - Concentrated Cadmium Seleno Sulphide (CC). *ASTM Lightfast rating* - In all media I: Excellent. *Transparency* - Opaque. *Staining power* - Slight. *Drying* -Dries very slowly forming a fairly strong film as an oil paint. Low to medium oil content.

Cadmium Red Medium or Deep

CADMIUM RED MEDIUM or DEEP
Lightfastness
Watercolours I: Excellent
Oils I: Excellent
Acrylics I: Excellent
Gouache I: Excellent
Alkyds I: Excellent
PR 108

All Cadmium Colours - the yellows, orange and reds - are from the same basic 'family' and are very close in make up.

They all share the same admirable qualities: strong, bright colours which handle well and are absolutely lightfast.

The colour varies from a bright deep orange-red to a deeper violet-red.

It is quite possible to find Cadmium Red Mediums which are deeper in hue than Cadmium Red Deep and deep versions of the colour which are lighter than the medium.

So choose carefully if you are seeking a particular hue.

If you decide on either the medium or deep version of this colour always select the finest quality.

Student versions of either colour will always give very inferior results.

Such colours can usually be identified by the use of the word 'Hue' or 'Azo' following the name.

Many of these imitations are produced from very poor materials and the colour fades quite quickly. It really is not worth it for the sake of a little extra money.

Besides, think of what earlier artists would have paid for such superb colours had they been available.

It is possible to find the genuine pigment as a Student colour at a lower price than Artist's quality, so always check the ingredients.

Recommended

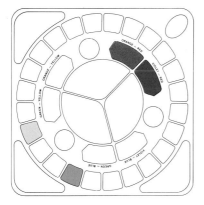

The mixing complementaries are: For the violet-red version, yellow-green, and for the orange-red examples, a blue-green.

Mixing tips

As mentioned above, the colour varies from a deep orange-red to a dark violet-red. If you wish to darken the colour further it is important to choose the mixing partner with care.

If working with an orange-red version darken with a blue-green, if you have a violet-red use a little yellow-green to deepen the colour further.

Use a blue-green to darken the orange version

and yellow-green if working with a violet - red.

Technical information: *Common Name* - Cadmium Red Medium or Deep. *Colour Index Name* - PR108. *Colour Index Number* 77202. *Chemical Class* - Concentrated Cadmium Seleno Sulphide (CC). *ASTM Lightfast rating* - In all media I: Excellent. *Transparency* - Opaque. *Staining power* - Slight. *Drying* - Dries very slowly to a fairly strong film as an oil paint. Medium oil content.

Carmine

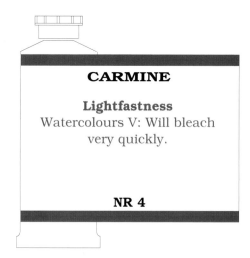

CARMINE

Lightfastness
Watercolours V: Will bleach
very quickly.

NR 4

Carmine, produced from the bodies of tiny beetles, is also used to colour cake icing, where it is sold under the name Cochineal. You never know what you are eating!

Genuine Carmine is produced from the dried bodies of a tiny beetle native to Central America.

This material is marketed with a fair amount of hype and sold heavily on 'tradition' and the skills required to manufacture it.

Yet any company offering this substance for artistic use knows full well that the colour has little resistance to light.

It will fade rapidly, even under incandescent illumination.

A most worthless substance that will have ruined many thousands of carefully executed paintings.

There are imitation Carmines on the market employing a variety of pigments.

These vary in reliability, some are lightfast whilst others will deteriorate rapidly.

Check with the pigments list at the end of this section if you find the name appealing.

Otherwise , why help to retain a description from the past - a description used to sell all manner of substances.

Do not be taken in by the common practice of selling PR83 Rose Madder Alizarin or PR83:1 Alizarin Crimson (both unreliable), under this name.

Not recommended if genuine.

Check ingredients in imitations.

Mixing tips

Carmine, whether genuine or imitation, is a violet-red.

In value it varies from a reasonably bright colour to a deep dull hue.

If you wish to work with such colours it is an easy exercise to darken a reliable violet-red.

I would suggest using Quinacridone Violet (see page 52), as the base colour and darkening with either Viridian or Phthalocyanine Green.

By darkening, or neutralising, a lightfast violet-red with a suitable green, a wide range of 'Carmine' type colours can be produced with ease. All will be reliable.

Technical information: *Common Name* - Carmine. *Colour Index Name* - NR 4 (Natural red 4). *Colour Index Number* 75470. *Chemical Class* - Natural pigment made from Cochineal insect. *ASTM Lightfast rating* - Failed testing as a watercolour, V: Pigment will bleach very quickly. *Transparency* - Transparent.

Crimson Lake

The name Crimson Lake is yet another way for manufacturers to off load the worthless substance PR83:1 Alizarin Crimson.

Either this or yet another cheap industrial colorant prone to fading. Occasionally you will find the excellent PV19 Quinacridone Violet offered under this description.

If you do, it will be a reliable paint, but ask yourself if you wish to help retain this meaningless name from the past (Crimson). A name which continues to add to the confusion.

Besides, Quinacridone Violet should be sold under its own name.

It might sound less romantic but at least you know what you are purchasing.

Not Recommended

Scarlet

Nowadays the term 'Scarlet' is quite meaningless. It is a name used to market a mixed bag of reds.

Some of these will be reliable, others will fade or darken quite quickly. If tempted by the name, check the pigments used very carefully.

They will range from the unreliable PR83:1 Alizarin Crimson, the entirely unsuitable PR3 Toluidine Red to the superb PR108 Cadmium Red.

Only consider a purchase if satisfied as to the pigments used and you wish to encourage the manufacturers to continue the confusion of colour names.

Not Recommended

Quinacridone Violet & Quinacridone Red

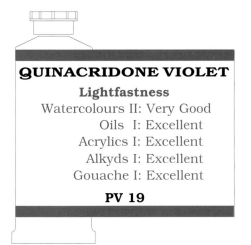

QUINACRIDONE VIOLET

Lightfastness
Watercolours II: Very Good
Oils I: Excellent
Acrylics I: Excellent
Alkyds I: Excellent
Gouache I: Excellent

PV 19

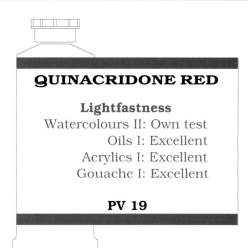

QUINACRIDONE RED

Lightfastness
Watercolours II: Own test
Oils I: Excellent
Acrylics I: Excellent
Gouache I: Excellent

PV 19

One good violet-red and a suitable orange-red will be all that you will normally ever require.

These two, together with two suitable blues and a pair of carefully selected yellows will give several million mixes.

The ideal all round violet-red, to my mind, is either Quinacridone Violet or Quinacridone Red.

Both are very bright, extremely transparent and lightfast.

In every respect they out class Alizarin Crimson, a colour that either or both will hopefully replace on the average artist's palette.

They brush out more smoothly in all media, give violets which are far brighter when mixed with Ultramarine Blue and above all, are lightfast.

For reasons of their own, manufacturers of artists' paint prefer to sell these closely related colours under a variety

of fancy or trade names.

If they all used the correct name, artists would come to recognise their true value and purchase accordingly.

But it does not quite work that way.

Both are worth seeking out, even if it means checking the ingredients used in a wide variety of reds.

Sold under such names as 'Permanent Rose' 'Red Rose Deep' and 'Ruby Red'.

Recommended

Mixing tips

If you wish to darken either of these violet-reds, add their mixing partner, yellow green.

Either version will darken and stay in character by the addition of small amounts of yellow green.

Bright, transparent and lightfast violets are available by mixing with a good quality Ultramarine Blue.

Technical information: *Common Name* - Quinacridone Violet or Quinacridone Red. *Colour Index Name* - PV19. *Colour Index Number* 73900. *Chemical Class* - Quinacridone B & Y forms. *ASTM Lightfast rating* - Quinacridone Violet -Oils, alkyds, acrylics and gouache rated I: Excellent, in watercolours rated II: Very good. Quinacridone Red - Oils, acrylics and gouache rated I: Excellent. *Transparency* - Transparent. *Staining power* - high. *Drying* - Medium to slow drying as an oil paint.

Rose Madder

ROSE MADDER

Lightfastness
Watercolours IV: Fugitive
Oils II: Very good

Not tested in other media

NR 9

Produced from the root of the Madder plant, genuine Rose Madder has very little going for it, despite the hype that surrounds it.

Are you a watercolourist, drawn by romantic names and susceptible to 'hype' ?

If so, go for genuine 'Rose Madder'. Produced from the root of the Madder plant, it should have become obsolete decades ago, as it is prone to rapid fading and discoloration.

Imitations are usually PR83 Rose Madder Alizarin or PR83:1 Alizarin Crimson; both without merit.

Best left alone unless you wish to produce short - lived work.

Suitable for use when made up into an oil paint and will probably be reliable as an acrylic. However, imitations are the norm in these media so check the ingredients carefully.

Not recommended as a watercolour if the genuine pigment has been used.

Technical information: *Common Name* - Natural Rose Madder. *Colour Index Name* - NR 9 (Natural Red 9). *Colour Index Number* 75330. *Chemical Class* - Natural Madder. A*STM Lightfast rating* - In watercolour IV: Will fade rapidly. Oils II: Very Good. *Transparency* - Transparent.

Madder Lakes

If you like wandering through minefields then this name should attract you.

A variety of 'Madder Lakes' are available, from 'Madder Lake Light' to 'Madder Lake Deep'.

Most are produced using the unreliable PR83:1, Alizarin Crimson. (Vast amounts of this substance are sold to the unwary).

Alizarin Crimson is sometimes replaced by an equally worthless pigment.

Of eleven 'Madder Lake' watercolours (for example) on the market, *only one* will not fade rapidly. It is a similar story elsewhere.

This is a definite trap for the unwary.

To my mind, the amazing thing is that many an artist, having decided upon a favoured manufacturer, will not react on discovering that the same producer will offer quite worthless colours under the guise of a 'traditional' name. Colours which the producer knows will quickly deteriorate.

It should be clearly understood by all that there is no need whatsoever for any colour which is less than lightfast to be on the market.

I would challenge any manufacturer to produce a 'Madder Lake' which could not be matched, through mixing, using lightfast pigments.

The excuse that such colours are unique and are in 'demand' is no longer good enough.

Not recommended.

Vermilion

VERMILION

Lightfastness
Watercolours III: Not lightfast
Oils I: Excellent
Acrylics I: Excellent

Alkyds and gouache not tested

PR 106

The forerunner of Vermilion was Cinnabar, produced from a hard rock. Vermilion is the synthetic version of Cinnabar.

The first reasonably bright red of the ancient world was Cinnabar.

Produced (with difficulty) from a very hard rock, it was highly valued and traded extensively, particularly around the Mediterranean.

The colour was later produced synthetically and came to be known as Vermilion. It remained a highly valued pigment for hundreds of years.

A bright, intense orange-red with good covering power.

Today it is more than adequately replaced by Cadmium Red Light. A pigment very similar in colour and handling qualities.

One of the main reasons for the gradual demise of Vermilion, a demise taking place right now, is due to the fact that it can darken quite dramatically.

Exposure to light and the atmosphere can cause the original bright orange red to become almost black. This factor makes it quite unsuitable for use as a watercolour or gouache.

This has not prevented manufacturers offering the colour in these media.

Although less frequently used in recent years, it is still available and will certainly still have a presence in many an artist's paint box.

If you have this colour as either a watercolour or a gouache I suggest a careful examination of the pigments used.

If you have an artificial version it might be lightfast, if you have the genuine article I would suggest that you discard it or use it only for sketch work.

The binder used in both oil paints and acrylics does seem to offer a great deal of protection as the colour tested very well in these media.

Given the choice I would always select Cadmium Red Light as my opaque orange-red - in all media.

Recommended as an oil paint or an acrylic.

Not recommended as a watercolour or gouache.

As Vermilion is very similar in hue to Cadmium Red Light, please see 'mixing tips' for that colour on page 48. This will show the ideal way to darken the colour.

As the orange-red and blue-green approach each other in intensity, some very useful coloured greys will result.

please see 'mixing tips' for that colour on page 48.

| **Mixing tips** |

These will readily harmonise with the red and the green.

Add white to any of these greys to produce subtle tints.

Technical information: *Common Name* - Vermilion. *Colour Index Name* - PR 106. *Colour Index Number* 77766. *Chemical Class* - Mercuric Sulphide. *ASTM Lightfast rating* - In watercolour 111: Can deteriorate rather badly, particularly in tints. *Transparency* - Semi-opaque to opaque. *Staining power* - slight. *Drying* -Very slow drier forming a strong film as an oil colour. Low oil content.

Miscellaneous reds

At the time of writing some 60% of miscellaneous red paints on the market (Artist and Student qualities) will either fade rapidly or darken on exposure to light.

Whether in watercolours, oils, acrylics or (particularly) gouache, little concern is shown by many manufacturers towards the artist. If a name can be chosen which is appealing and the product sells well - it does not seem to matter what pigments are chosen.

In a book of this nature, it is impossible (and unnecessary) to list all colour names used to sell the various reds, and it would not be necessary. If you check the ingredients, which should always be given, with the list to be found on the following two pages, you will be able to choose with confidence.

Amongst the 40 or so percent of reliable reds on offer, you will find many examples of lightfast reds such as PV Quinacridone Violet. Such colours are perfectly acceptable.

Be particularly alert towards the use of PR3 Toluidine Red. This can be classed as an inferior industrial pigment. It is an inexpensive pigment used extensively in the printing industry. Even printers, who usually have no need to be concerned about lightfastness, regard it as a dull, weak red which fades quickly. Personally, if I found it in use, either alone or in a mix, I would question the integrity of the manufacturer.

Another trap which can be set for the artist is to offer one or other of the brilliant, fluorescent industrial reds. PR81 Rhodamine Y is a good example of this approach. It leaves the tube as a very bright, transparent violet-red, but soon becomes a dull, discoloured shadow of its former self.

However, it can be packaged under a fancy name and sold with ease. The uninformed are easily seduced by the strength of colour on opening a tube in the art store, or when choosing via a catalogue. Be wary of all Rhodamine colours.

The end result (shown above on the right) of using a red containing PR90 Phioxine Red will hopefully encourage you to always check the ingredients in any paint.

PERMANENT RED

Another 'come on in, you will be quite safe' approach is to describe a known fugitive colour as 'Permanent Red'. Some Permanent Reds are, but the majority are most definitely not.

'Permanent Rose' is a name commonly used for a violet-red produced from the excellent PV19 Quinacridone Red or Violet. However, at least one manufacturer uses the name to market the notoriously unreliable PR60 Scarlet Lake. The illustration above shows the extent to which this particular red can fade.

Be very wary when purchasing other than the standard, established reds with a known history. Ask yourself if the reason for so many fanciful names might just be something to do with a marketing exercise.

Red pigments to choose or avoid

The following pigments have not all been subjected to ASTM testing. Where they have not, I am offering guidance based on other independent testing as well as my own.

Reliable pigments - all have been subjected to vigorous testing.

PR 5 Napthol ITR - tested acrylics, oils & gouache II: Very Good. In our own tests, using the pigment as a watercolour, our sample faded - use with caution in this media. See note next page.

PR 7 Napthol AS-TR - tested acrylics & oils I: Excellent. Suitable for these media but not for watercolour or gouache. See note next page.

PR 9 Napthol AS-OL - tested I: Excellent, in alkyds and II: Very Good in oils & gouache.

PR 14 Napthol AS-D - tested II: Very Good in acrylics, gouache & oils.

PV 19 Quinacridrone Red - ASTM I: Excellent as oils & acrylics. II: Very Good in own watercolour tests.

PV 19 Quinacridrone Violet - tested I: Excellent in oils, acrylics, alkyd and gouache II: Very Good as a watercolour paint.

PR 101 Indian Red - tested I in oils, alkyds, acrylics and watercolour.

PR 101 Light or English Red Oxide - tested I: Excellent, in oils, alkyds & acrylics.

PR 101 Mars Red, (or Iron Oxide Red) - tested I: Excellent, in oils, acrylics & gouache.

PR 101 Venetian Red - tested I: Excellent in oils, watercolours & acrylics.

PR 102 Light Red - tested I: Excellent in watercolours, oils & acrylics.

PR 106 Vermilion - tested I: Excellent in oils and acrylics. Suitable in these media but failed testing as a watercolour. See note next page.

PR 108 Cadmium Red Light, Medium or Deep tested I: Excellent, in all media.

PR 108:1 Cadmium-Barium Red Light, Medium or Deep - tested I: Excellent in oils, acrylic & watercolour.

PR 112 Napthol AS-D - tested II: Very Good in oils & acrylic but failed testing as a watercolour. See note next page.

PR 113 Cadmium Vermilion Red Light, Medium, or Deep - tested I: Excellent in oils, acrylics & gouache.

PR 113:1 Cadmium-Barium Vermilion Red Light Medium or Deep - tested I: Excellent, in oils, alkyds & acrylics.

PR 119 Napthol Red - tested I: Excellent in oils, alkyds & acrylic.

PR 122 Quinacridone Magenta -tested well with a rating of I: Excellent, in oils, alkyds & acrylic, and II: Very Good, as a gouache.

However, failed testing as a watercolour. See note next page.

PR 123 Perylene Vermilion - tested I: Excellent in oils & II: Very Good, as an acrylic.

PR 149 Perylene Red *BL* - tested well in our testing as a watercolour and enjoys a good reputation.

PR 149 Perylene Red - tested I: Excellent in oils & acrylic.

PR 166 Disazo Scarlet - tested well in our testing as a watercolour and enjoys a good reputation.

PR 168 Brominated Anthranthrone - tested II: Very Good as an oil paint & I: Excellent as an acrylic.

PR 170 (F3RK-70) Napthol Red -tested well with a rating of II: Very Good in oils & I: Excellent in acrylics & gouache.

PR 170 F5RK Napthol Crimson - tested II: Very Good, as an oil paint, an alkyd & an acrylic.

PR 171 Benzimidazolone Bordeaux - tested I: Excellent as an acrylic.

PR 175 Benzimidazolone Maroon - tested I: Excellent in oils & acrylics.

PR 178 Perylene Red - tested II: Very Good as a watercolour.

PR 179 Perylene Maroon - tested I: Excellent when made up into an oil paint and an acrylic.

PR 187 Napthol Red HF4B - tested II: Very Good in own testing as a watercolour. No other test results are available.

PR 190 Perylene Red - tested I: Excellent in oils and acrylics.

PR 192 Quinacridone Red- tested I: Excellent in oils & acrylics & II own testing as w/col.

PR 194 Perinone Red Deep - tested oils & acrylics I: Excellent.

PR 207 Quinacridone Scarlet - tested as I: Excellent when made up into an oil or acrylic.

PR 209 Quinacridrone Red Y - tested very well as a watercolour with a rating of I: Excellent.

PR 216 Pyranthrone Red - tested very well in own testing and has a good reputation

PR 242 Sandorin Scarlet 4RF - not tested under ASTM conditions. Our tests as a watercolour paint were positive.

PR 181 Thioindigoid Magenta - tested I: Excellent, in acrylics.

PR 209 Quinacridrone Yellow Red - tested I: Excellent when made up into an acrylic paint.

Suitable in certain media but will tend to fade as a watercolour and generally as a gouache.

PR 5 Napthol ITR - tested well in acrylics, oils & gouache. In our own tests, using the pigment made up into a watercolour, our sample faded - use with caution in this media.

PR 6 Parachlor Red - tested III own testing.

PR 7 Napthol AS-TR - tested acrylics & oils I: but failed testing as a watercolour or gouache. Use with caution in these media.

PR 48:4 Permanent Red 2B (Manganese) - own testing in watercolour suggests caution. Might be suitable in other media.

PR 106 Vermilion - suitable oils & acrylic, but failed testing as a watercolour.

PR 112 Napthol AS-D - lightfast in oils & acrylic but failed testing as a watercolour.

PR 122 Quinacridone Magenta - lightfast in oils, alkyds, acrylic and gouache but failed ASTM testing as a watercolour.

PR 177 Anthraquinoid Red - not yet tested in any media. Our own observations suggest caution when made up into a watercolour.

Most unsuitable for artistic use - poor to very poor lightfastness.

Certain of the following might prove reliable in oils, acrylics or alkyd but all have failed convincingly in other areas. Why take the chance of using them?

PR 2 Napthol Red FRR - failed all lightfast testing.
PR 3 Toluidine Red - failed ASTM testing in gouache and own testing as a watercolour.
Natural Red 4 Carmine - resoundingly failed ASTM testing as a watercolour.
PR 4 Permanent Red R - failed ASTM testing in gouache and own testing as a watercolour.
NR 9 Natural Rose Madder - failed ASTM testing as a watercolour. Suitable for oils & alkyds.
BR12 Astra Phloxine Lake - failed ASTM testing as a gouache.
PR 12 Napthol AS-D - failed ASTM testing in gouache and own testing as a watercolour.
PR 23 Napthol AS-BS - failed ASTM testing in gouache and own testing as a watercolour.
PR 31 Napthol AS-BS - failed ASTM testing in gouache and own testing as a watercolour.
PR 48:1 Permanent Red 2B (Barium) convincingly failed own testing as a w/col.
PR 48:2 Watchung Red or Permanent Red 2B failed ASTM testing as a gouache.
PR 48:3 Permanent Red 28 - failed ASTM testing as a gouache.
PR 49:1 Lithol Red 15630:1 - failed ASTM testing in gouache and own testing as a watercolour.
PR 52:2 Lithol Red 2G - failed ASTM tests as a gouache.
PR 53:1 Red Lake C (Barium) - failed our own testing and has a poor reputation.

PR 57 Lithol Rubine (Sodium) - failed own testing as a w/col plus has a poor reputation.
PR 57:1 Lithol Ruhine B - failed ASTM tests as a gouache plus has a very poor reputation.
PR 60 Scarlet Lake (Sodium) - failed our own testing and has a very poor reputation.
PR 60:1 Pigment Scarlet 3B 16105:1 - failed ASTM tests as a gouache.
PR 81 Rhodamine Lake - failed ASTM testing in gouache and own testing as a watercolour.
PR 82 Rhodamine Yellow Shade - convincingly failed our own testing & has a poor reputation.
PR 83 Rose Madder Alizarin - failed ASTM testing in gouache and own testing as a watercolour.
PR 83:1 Alizarin Crimson 58000:1- failed ASTM testing as a w/col and has a poor reputation.
AR 87 Eosine Lake - failed ASTM testing as a gouache.
PR 90 Phioxine Red - failed our own testing as a w/col. Also has a very poor reputation.
PR 105 Red Lead - failed own testing convincingly.
PR 146 Napthol Red - failed ASTM testing as an oil and acrylic. Failed our own tests as a watercolour.
PR 170 F5RK Napthol Crimson - failed ASTM testing as a gouache.
PR 173 Rhodamine - dramatically failed our own testing, a disastrous substance which should not even be offered.

Introduction to violets

The early 'coal tar' violets attracted great attention. They were bright and relatively inexpensive.

Regrettably, most were introduced without extensive testing and many tended to fade rapidly. Those that proved reliable are fortunately still with us.

Painting: April Love (1856) by Arthur Hughes. Courtesy The Tate Gallery, London.

The earliest unmixed violet, Tyrian purple, was obtained from the body of a species of whelk found in the Mediterranean. It was prohibitively expensive and was used almost exclusively by the likes of the latest Caesar and his Senators. From these beginnings purple became known as a royal colour.

Over the ages, various other violet dyes were introduced for use in the manufacture of 'lake 'colours, but the big break through came in the mid 1800s with the discovery of 'coal tar' colours.

These bright, strong violets were often hurried into production without adequate testing. Unfortunately most were fugitive and destroyed many a painting.

In some ways not a lot has changed. To-gether with a limited range of reliable pigments, artists are still being offered, and still widely use, violets which will fade or darken rapidly. Such colours can only lead to the deterioration of a painter's creative effort.

Personally I find little use for any of the commercially available violets. Quinacridone violet (a violet-red) and Ultramarine Blue (a violet-blue) will combine to give a very wide range of clear, bright, red to blue violets.

These can be further modified by adding one or other type of yellow. Mid and greyed violets can also be mixed with ease by introducing an orange red and a green blue.

The skills required to produce a wide range of reliable, repeatable *lightfast* violets are easily assimilated.

Cobalt Violet

COBALT VIOLET

Lightfastness
Watercolours I: Excellent
Oils I: Excellent
Gouache I: Excellent

Alkyds and acrylics not tested but
will almost certainly be lightfast in both media

PV 14

Two versions are available, Cobalt Light and Dark. Either version might also be described simply as Cobalt Violet.

This is a colour which painters tend to either love or hate. I must admit that I am in the latter camp.

I personally find it difficult to work with in oils or watercolour. The pigment is rather weak and the finished paint seldom has any 'body'.

This is particularly the case with watercolours produced from this pigment.

Almost without exception, Cobalt Violet watercolours are more like a coloured gum than a workable paint, weak, difficult to brush out and often very grainy.

However, these are my personal observations and are obviously subjective.

If you find the paint handles as you wish, at least you can be sure that it will not fade, in any media.

A transparent colour which varies considerably in hue, from a red to a blue - violet.

The word 'hue' after the name will indicate an imitation but a certain amount of deception does take place.

As examples of this, a certain 'Cobalt Violet Pale Genuine' is produced from Manganese Violet (please see next page), and an Artist's quality 'Cobalt Violet' is a mix of Cobalt Blue and Quinacridone Red.

Both of these paints are lightfast and handle well, but neither is Cobalt Violet.

Ask yourself if you really need it as it is easily duplicated on the palette using colours with superior handling qualities.

The genuine article is usually rather expensive.

Recommended only if you find a version which you feel handles well.

Mixing tips

As mentioned, the colour varies from a red to a blue violet. However, most versions lean towards red.

As the mixing partner of a red-violet is a green-yellow you will find that most 'Lemon Yellows' will darken the colour well. Green-yellows such as Arylide Yellow 10G (Hansa Yellow Light) or Cadmium Yellow Lemon are ideal.

Technical information: *Common Name* - Cobalt Violet. *Colour Index Name* - PV 14. *Colour Index Number* 77362 or 77360. Chemical *Class* - Cobalt Ammonium Phosphate or Cobalt Phosphate. A*STM Lightfast rating* - Watercolour, oils and gouache tested I: Excellent. Not yet tested in Alkyds or Acrylics. *Transparency* - Transparent. *Staining power* - Slight. Drying - Average to fast drier forming a brittle film as an oil colour. Medium to high oil content.

Manganese Violet

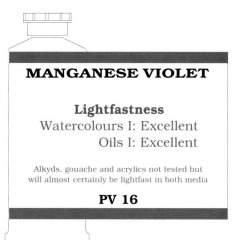

MANGANESE VIOLET

Lightfastness
Watercolours I: Excellent
Oils I: Excellent

Alkyds, gouache and acrylics not tested but
will almost certainly be lightfast in both media

PV 16

I can see very little need for manufactured violets as a vast range of bright hues can be mixed from a violet-red such as Quinacridone Violet and Ultramarine, a violet-blue.

These brighter mixes can then be darkened gradually by the addition of the appropriate yellow.

With a means of creating tints, either by employing a white background or adding white paint, the potential range runs into tens of thousands. The commercially available violets are all easily duplicated from amongst this vast range, both in hue and in brightness.

Although fast to light, with excellent test results, it is susceptible to damp, turning brown on prolonged exposure.

For this reason, when used as a watercolour it should be well protected under glass and kept away from dampness.

Manganese Violet is sold under its own name as well as others, such as 'Permanent Mauve' and 'Mineral Violet'.

A rather dull, red to mid violet which is low in tinting strength. Absolutely lightfast.

This is an opaque colour which covers well. If you require such opacity then this will be a more suitable violet than those that I have suggested could be mixed - both contributing colours being transparent.

The Artists' quality will be a good buy if you have a need for such a colour.

Recommended

| **Mixing tips** |

Add Ultramarine Blue (a violet-blue), to move the colour towards semi-transparent blue-violets, which remain reasonably bright.

Added Quinacridone Violet (a red-violet), will give semi-opaque to semi-transparent red violets which are fairly bright.

Use Cerulean Blue (a green-blue), for opaque, dulled blue violets.

For dull, opaque red violets mix with Cadmium Red Light, an opaque orange-red.

Technical information: *Common Name* - Manganese Violet. *Colour Index Name* - PV 16. *Colour Index Number* 77742. *Chemical Class* - Manganese Ammonium Pyprophosphate. *ASTM Lightfast rating* - Watercolour and oils tested I: Excellent. Not yet tested in alkyds or acrylics or gouache. *Transparency* - Semi-opaque to opaque. *Drying* -Dries quickly in oils due to the Manganese content. Very high oil content.

Mars Violet

MARS VIOLET

Lightfastness
Watercolours I: Excellent
Oils I: Excellent
Acrylic I: Excellent

Alkyds and gouache not tested but
will almost certainly be lightfast in both media

PR 101

The Mars colours: Yellow, Red, Brown, Orange, Black and Violet are all artificial mineral pigments designed to replace the natural earth colours of similar hue.

All are strong, handle well and are inexpensive, (or they should be).

They are also very opaque, to the degree that many artists prefer the natural earths for their added degree of transparency.

Mars Violet is a rather subdued, brownish violet produced by the further heating of Mars Yellow.

It is very lightfast, having passed all tests of which I have record, with flying colours. It is on the list of ASTM approved pigments, having satisfied their very demanding lightfast test procedures.

An opaque colour which covers particularly well - too well for many watercolourists.

It is quite strong in tinting strength and will play its part in colour mixing.

Although I will recommend it because it is lightfast and handles very well, it has to be said that it is a colour which is very easily duplicated on the palette.

Fine if you see it as a useful convenience colour in your work, but do you really need it?

Recommended

Mixing tips

The fact that this is a very opaque colour should be taken into account when colour mixing. If blended with other opaque or semi-opaque colours it will give predictable results. But if transparent or semi-transparent colours are added it will pay to apply some of the mix to one side of the painting before using, in order to ascertain the final transparency.

The colour offered is not uniform as much depends on the original pigment manu-

facturer - when has the base Mars Yellow cooked enough to form the required colour? It will vary from one manufacturer to another.

A similar range of brown violets to those available in the various Mars Violets on

offer can be produced by darkening Cadmium Red Light with a blue-green mixed from a quality green-yellow, such as Hansa Yellow Light (page 23) and Cerulean Blue.

Such mixes will be similar in hue and also opaque.

Technical information: *Common Name* - Mars Violet or Violet Iron Oxide. *Colour Index Name* - PR 101 *Colour Index Number* 77015. *Chemical Class* - Synthetic iron oxide (violet hue). *ASTM Lightfast rating* - Watercolour, oils and acrylic tested I: Excellent. Not yet tested in alkyds or gouache. *Transparency* - Usually opaque but fairly transparent varieties are available. *Drying* -Dries well as an oil colour forming a durable film. Medium oil content.

Ultramarine Violet

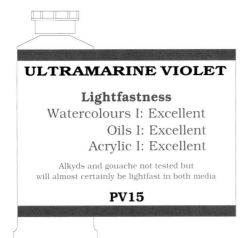

ULTRAMARINE VIOLET

Lightfastness
Watercolours I: Excellent
Oils I: Excellent
Acrylic I: Excellent

Alkyds and gouache not tested but
will almost certainly be lightfast in both media

PV15

Ultramarine Violet is produced by heating Ultramarine Blue in the presence of certain chemicals.

When this colour, in turn, is heated alongside gaseous acids, it gives Ultramarine Red

A violet which leans towards blue, Ultramarine Violet is easily duplicated by mixing Quinacridone Violet and Ultramarine Blue.

Although such a mix will give a very similar hue, it will not be as opaque as Ultramarine Violet.

Its opacity is really the only characteristic which sets it apart.

Rather weak in tinting strength, the main attraction is that it is, or should be, a relatively inexpensive violet.

Another valuable feature, although for a limited audience, is that it is one of the very few prepared violets which are suitable for fresco work, being unaffected by alkalis.

This colour is often accompanied by a rather strange odour, similar to coal gas.

The odour remains with the applied paint for some time and is due to the manufacturing process.

The fact that it was rated I:

Excellent as a watercolour indicates its reliability.

Watercolours do not have the protection offered by other binders, so to rate so highly the pigment must be absolutely lightfast.

Although sold under its own name, you might come across its use in mixes given fancy or trade names.

Although I would find little use for an easily mixed, rather weak blue-violet, its opacity might make it useful to you, particularly if you take up painting onto wet plaster.

Recommended
with certain reservations

Mixing tips

Similar blue violets are easily produced by mixing a reliable violet-red such as Quinacridone Violet and Ultramarine Blue, a violet-blue.

These blue-violets will be similar in hue to Ultramarine Blue but will be more transparent.

As such they will possibly be of greater value to the watercolourist than Ultramarine Violet.

As with most prepared violets, it is often better to mix your own from ingredients which you know are reliable.

Technical information: *Common Name* - Ultramarine Violet. *Colour Index Name* - PV 15 *Colour Index Number* 77007. *Chemical Class* - Complex Silicate of Sodium & Aluminum with Sulphur. *ASTM Lightfast rating* - Watercolour, oils and acrylic tested I: Excellent. Not yet tested in alkyds or gouache. *Transparency* - Opaque.

Miscellaneous violets

The miscellaneous colours in this area come under four main headings, magenta, mauve, purple and violet.

Magenta

This is a name in common use throughout the printing industry for their principal red. When it comes to artists' colours, the name is used in a rather loose fashion to describe a range which varies from a bright violet-red to a very dull blue-violet. Several examples are shown above

The pigments used to produce this range vary from reliable to fugitive. Be very wary of the use of PV39 Crystal Violet. It discolours and darkens as shown above.

Mauve

Mauve was originally the name given to a coal tar dye discovered by William Perkin in 1857. It was one of many such colours from this source, most of which proved to be disastrous when used in artists paint. Mauve was very fashionable in its day and the name is still widely used in a general way.

As an artists' colour, it covers a range of violets which vary from red to blue; the latter being the most prevalent. Also prevalent is the use of unreliable pigments. Some 90% of watercolours for example, sold under this name, will fade dramatically.

In particular be wary of PV23 (RS-red shade or BS- blue shade), Dioxazine Purple, if choosing a watercolour or gouache.

Purple

Whereas mauves are usually blue-violets, purples usually lean towards red. The range available varies from bright red to very dull, almost brown-violets. Do check the ingredients, as a high proportion of 'purples' are very fugitive.

Fancy violets

The majority of violets carrying a fancy or trade name will fade or darken rapidly.

Standard violets

The following standard violets are worth considering if you find the colour to be of value.

Ultramarine Red

PV15 Ultramarine Red - CIN 77007. A very reliable violet which rated ASTM I: Excellent in both watercolours and acrylics. The fact that it rated so well as a watercolour suggests that it will be lightfast in all media.

Ultramarine Violet

PV15 Ultramarine Violet has the same basic chemical make-up and CIN (Colour Index Number), as Ultramarine Red, above. Rated ASTM I: Excellent in watercolours, oils and Acrylics. Not yet tested in Alkyds but will almost certainly prove to be lightfast.

Mars Violet

PR101 Mars Violet might also be called Violet Iron Oxide. The CIN is 77015. This is a reliable synthetic iron oxide. Tested ASTM I: Excellent in watercolours, acrylics and oils. Not yet tested as an alkyd but should be lightfast.

Manganese Violet

PV 16 CIN 77742 Manganese Violet rated ASTM I: Excellent in oils and alkyd.

It could be argued that a prepared violet is a convenience colour. But unless it is always used direct from the tube or pan, it will be mixed with other colours anyway. Why not simply mix it to start with?

Violet pigments to choose or avoid

The following pigments have not all been subjected to ASTM testing. Where they have not, I am offering guidance based on other independent testing as well as my own.

Reliable pigments - all have been subjected to vigorous testing.

BS14 Cobalt Violet - tested ASTM I: Excellent in oils, watercolour and gouache.

PV15 Ultramarine Red - tested I: Excellent in watercolours, oils and acrylics.

PV15 Ultramarine Violet - tested I: Excellent in watercolours, oils and acrylics.

PV16 Manganese Violet - tested I: Excellent in watercolours and oils.

PV19 Quinacridone Red - ASTM tested I: Excellent in oils & acrylics. Own testing as a watercolour II: Very Good.

PV23 BS Dioxazine Purple - tested II: Very Good, in oils and acrylics. Failed testing as a watercolour with a rating of IV (Will fade rapidly).

PV 31 Isoviolanthrone Violet - tested ASTM I: Excellent in oils and acrylic.

PV46 Graphtol Violet CI-4RL - tested II: Very Good own testing and has a good reputation.

PV49 Cobalt Ammonium Violet Phosphate - tested II: very Good in own test as a watercolour.

PR88 (MRS) Thioindigoid Violet - tested ASTM I: Excellent in oils, acrylics and gouache. Own test as a watercolour II: Very Good.

PR101 Mars Violet - tested I: Excellent, in oils, acrylics and watercolour.

Suitable in certain media but will tend to fade as a watercolour and generally as a gouache.

PV23 BS or RS Dioxazine Purple - lightfast in oils and acrylics. Failed testing as a watercolour. Avoid in this media.

Most unsuitable for artistic use - poor to very poor lightfastness.

Certain of the following might prove reliable in oils, acrylics or alkyd but all have failed convincingly in other areas. Why take the chance of using them?

PV1 Rhodamine B - failed testing in gouache, V: (Will bleach quickly) & own tests.

PV2 Rhodamine Lake or Vivid Magenta 6B - failed ASTM testing as a gouache & as a watercolour.

PV3 Methyl Violet Lake - failed testing in gouache, V: (Will bleach quickly) & also failed own tests.

PV4 Magenta - failed own testing dramatically.

PV5:1 Alizarin Maroon - tested IV: (Fades rapidly), own testing. Poor reputation.

PV39 Crystal Violet Lake - conclusively failed ASTM testing as a gouache. Also own tests in various media.

Introduction to blues

The Church commissioned many paintings of a religious nature. The rich violet-blue of genuine Ultramarine served two functions: it was a symbolic colour and also a very expensive substance.

The colour added extra value to the finished work, on show to all as a measure of the wealth of the Church.

The extravagant use of gold leaf served much the same purpose.

It was a difficult colour for the unscrupulous artist to duplicate successfully, which added further value to the genuine hue.

A viewer with a trained eye would realise that the particular painting had cost a great deal of money. As there was an understandable reluctance to 'spoil' the colour through mixing, it was usually employed in a pure form, as in this example.

Painting. The Virgin in Prayer by Sassoferrato. Courtesy the National Gallery, London.

We often tend to look back at the work of earlier artists and feel that they must have had access to materials superior to our own, in addition to a range of techniques which have remained secret. How else could they have achieved such wonderful results?

The truth is that few 'secrets' remain and earlier artists struggled with a limited range of colours which were invariably inferior to our own and sometimes extremely expensive.

Ultramarine Blue is just one example of this inequality over the ages.

Originally produced from the semi precious stone Lapis Lazuli it was prohibitively expensive, taking a great deal of time and skill to produce.

Such was its value that the Church, on commissioning a painting, would often send a priest to stand over the artist to ensure that the Ultramarine pigment which they had provided was used without adulteration.

It was the most expensive and treasured pigment from the middle ages to the mid 1800s, when artificial Ultramarine was invented.

Nowadays we can just drop into our local art store and purchase a good quality Ultramarine blue without a second thought.

We now have at our disposal some of the finest blue pigments from the past, together with recent additions such as Phthalocyanine Blue, an excellent range of relatively inexpensive bright, strong lightfast blues.

But you still need to be on your guard when making a purchase. For their own reasons, manufacturers still offer certain blues which are known to fade or darken, and insist on continuing the confusion of names.

Cerulean Blue

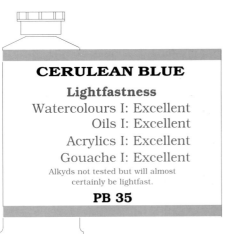

CERULEAN BLUE

Lightfastness

Watercolours I: Excellent
Oils I: Excellent
Acrylics I: Excellent
Gouache I: Excellent

Alkyds not tested but will almost
certainly be lightfast.

PB 35

The name is derived from the Latin 'Caeruleum', meaning 'sky blue pigment'. Two spellings are in use nowadays, Cerulean and Coeruleum.

A definite green-blue much valued as an 'atmospheric' colour.

It is opaque and covers very well, even in thin layers, but this does not prevent well produced versions brushing out quite thinly.

It is a rather heavy pigment which tends settle into pockets in the paper when used as a watercolour.

It will also separate from certain lighter pigments when applied as a very wet wash. The 'grainy' effect which results is much loved by watercolourists.

Check the texture before purchasing in any media as certain makes can be rather coarsely ground.

Although low in tinting strength it has a definite part to play in colour mixing, particularly when bright, opaque greens are sought.

Two versions are available, the Cerulean Blue PB 35 as described here and Cerulean Blue, Chromium PB 36.

Both possess similar characteristics (lightfast and opaque), but the latter is usually slightly brighter.

An excellent, all round green-blue which is absolutely lightfast in all media.

Recommended

Mixing tips

Cerulean Blue can be a very versatile colour for mixing purposes. This is particularly the case after a certain amount of experimentation has taken place.

Mix it with the different reds and yellows and observe not only the resulting colour, but also the transparency of the hue. The more you know about your colours, the better they will serve you.

Being an opaque green-blue it will give opaque, very

greyed violets with Cadmium Red Light (also opaque).

Dull, semi-opaque to semi-transparent neutralised mid-violets with the transparent Quinacridone Violet.

Bright, semi-opaque greens with a green-yellow such as Hansa Yellow Light.

And opaque mid-greens with Cadmium Yellow Light.

Technical information: *Common Name* - Cerulean Blue. *Colour Index Name* - PB 35. *Colour Index Number* 77368. *Chemical Class* - Oxides of Cobalt and Tin. A*STM Lightfast rating* - Watercolour, oils, acrylics and gouache tested I: Excellent. Not yet tested in Alkyds. *Transparency* - Opaque. *Staining power* - slight. *Drying* -Medium to slow drier forming a soft but non elastic film as an oil colour. High oil content.

Cobalt Blue

COBALT BLUE
Lightfastness
Watercolours I: Excellent
Oils I: Excellent
Acrylics I: Excellent
Gouache I: Excellent
Alkyds I: Excellent

PB 28

The word Cobalt is derived from the German 'Kobald', the goblin of the mines. The Cobalt Oxide crystals, reflected in the light of the miners lamp, appeared to be the flashing eyes of the goblin.

Often erroneously described as a 'pure, primary' blue, it does, like all blues, also reflect a certain amount of green and violet. There is no such thing as a pure blue, or any other colour for that matter.

Best described as a mid-blue which will lean either towards violet or green, depending on manufacturer.

It is most commonly biased towards green.

A rather weak colour with moderate covering power. The better qualities can be very transparent in thin applications.

As an oil paint it absorbs a great deal of oil during its preparation.

To help avoid later wrinkling of the paint film I would suggest that you do not apply very heavy layers or add extra oil, either directly or as a constituent in a painting medium.

An expensive colour but very popular in all media. Well worth the money if it is a colour that you require.

Unfortunately its popularity has encouraged many manufacturers to produce imitations. These are usually either Ultramarine and white or Phthalocyanine and white.

Where such a colour is described as a 'Hue', 'Imitation' or 'Tint' all is reasonably fair, but imitations are often offered as the genuine article.

It will be worth checking the actual pigment used to avoid being 'taken in', as so many artists are.

Recommended

Mixing tips

Whether the colour leans towards violet or green will need to be a consideration when choosing a suitable orange (the complementary), to darken it. A few experiments will soon show whether you need a red, mid or slightly yellow orange. The leaning, which is often very pronounced in imitations, will

A close match can be produced by mixing Ultramarine Blue and Phthalocyanine Blue.

also affect the types of green that will result when it is mixed with the various yellows.

Technical information: *Common Name* - Cobalt Blue. *Colour Index Name* - PB 28. *Colour Index Number* 77346. *Chemical Class* - Oxides of Cobalt and Aluminum. *ASTM Lightfast rating* - Watercolour, oils, acrylics, alkyd and gouache tested I: Excellent. *Transparency* - Semi opaque. *Staining power* - slight. *Drying* - Average to fast drier (due to the metallic content), forming a rather brittle film, prone to cracking as an oil colour. Very high oil content.

Indanthrone Blue

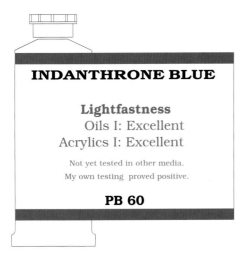

INDANTHRONE BLUE

Lightfastness
Oils I: Excellent
Acrylics I: Excellent

Not yet tested in other media.
My own testing proved positive.

PB 60

Although this pigment is lightfast in oils and acrylics, and might prove to be likewise in other media, it is not, to my mind of great value to the artist. A rather dull, slightly violet blue which loses much of its limited vibrancy in a wash. Semi opaque with poor covering power unless applied heavily. The colour is easily duplicated by adding Burnt Sienna to Ultramarine Blue. I will recommend it only because it might suit your requirements.

Recommended
with reservations

Technical information: *Common Name* - Indanthrone Blue. *Colour Index Name* - PB 60. *Colour Index Number* 69800. *Chemical Class* - Anthraquinone. *ASTM Lightfast rating* - Oils and acrylics I: Excellent, not yet tested in other media. My own test results as a watercolour were positive -II: Very Good. *Transparency* - Semi opaque.

Turquoise

TURQUOISE

Lightfastness
This is impossible to give as a variety of pigments are employed.

The Colour Index name varies

'Turquoise' is no more than a name used to sell a premixed blue green.

If you take Phthalocyanine Green and Phthalocyanine Blue and stir them together you will have the common, commercially available colour. It is hardly a convenience colour as it is so easily prepared during normal painting.

Most 'Turquoises' will be reliable but quite a few contain pigments which will fade or darken, as is often the case when you allow someone else to mix your colours.

Not Recommended

Technical information: *The details will vary depending on the actual ingredients used.*

Indigo

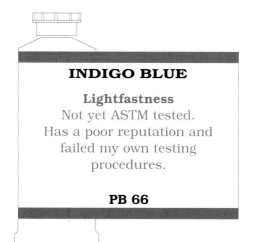

INDIGO BLUE

Lightfastness
Not yet ASTM tested.
Has a poor reputation and
failed my own testing
procedures.

PB 66

The leaves of the 'Indigo' plant were soaked in water until they fermented. They were then beaten to a mash and dried to form lump Indigo ready for export.

Genuine Indigo, produced from the leaves of the plant Indigofera Tinctoria, was imported into Europe from India from the early 1500s

It was a valuable item of commerce and played an important role in the British takeover of the Indian Sub Continent.

An artificial version was introduced in the late 1800s Modern Indigo, Pigment Blue 66, has a very poor reputation for reliability.

It has failed all lightfast testing for which I have record and faded dramatically during my own testing.

Fortunately it is now seldom used, although it is still out there, so be careful.

Instead, various mixtures more or less resembling the original colour are marketed under this name.

A common and very widespread practice is to sell a mix of Phthalocyanine Blue and a black, Prussian Blue and a suitable black or Phthalocyanine Blue, Ultra-

marine Blue and a black.

Sometimes a little Quinacridone Violet is thrown in, at other times it might be Alizarin Crimson.

Such mixtures vary from being lightfast to fugitive.

They are very easily duplicated on the palette using reliable colours. Please see below. Why encourage the continued use of a name from the past to sell almost any combination which give a dark black/blue.

Not recommended

Mixing tips

Such dark blue/blacks are very easily mixed from Burnt Sienna and Ultramarine Blue. The 'coloured greys' which result are very dark because a complementary blue/orange mix has been used and because both colours are transparent, allowing extra light to sink into the surface.

Technical information: *Common Name* - Indigo Blue. *Colour Index Name* - PB 66. *Colour Index Number* 73000. *Chemical Class* - Indigoid. *ASTM Lightfast rating* - Not tested in any media. Has a very poor reputation for resistance to light. *Transparency* - Semi transparent. *Staining power* - Quite high.

Manganese Blue

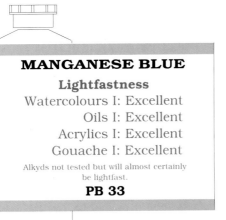

MANGANESE BLUE

Lightfastness

Watercolours I: Excellent

Oils I: Excellent

Acrylics I: Excellent

Gouache I: Excellent

Alkyds not tested but will almost certainly be lightfast.

PB 33

The production of genuine Manganese Blue pigment has all but ceased. Stocks held by colormen world wide are almost, if not completely, exhausted.

Although it would appear that the colour is departing the scene, there may well be paint stock held in art shops and there will certainly be many an artist with the colour in his or her paint box.

For these reasons alone, I will offer a description.

Manganese Blue is often thought of as a cheaper version of Cerulean Blue because it resembles that colour in hue.

However, it is usually a lot brighter, greener and certainly far more transparent.

A rather cold, brilliant green-blue which is resistant to light, heat, acids and alkalis.

Although once a lot less expensive than its close alternative, Cerulean Blue, this is not always the case nowadays as scarcity of supply can force the price up somewhat.

It makes a less than satisfactory watercolour in my opinion as the result is invariably a rather gummy colour which is difficult to wash out smoothly.

Not recommended

as a watercolour.

Recommended

if obtainable, in other media.

Mixing tips

Being a definite green-blue it will give reasonably bright greens with a green-yellow such as Hansa Yellow Light, and mid, semi opaque greens when mixed with Cadmium Yellow Light, which is an opaque orange-yellow.

Technical information: *Common Name* - Manganese Blue. *Colour Index Name* - PB 33. *Colour Index Number* 77112. *Chemical Class* - Barium Manganate with Barium Sulphate. *ASTM Lightfast rating* - Watercolour, oils, acrylics and gouache tested I: Excellent. Not yet tested in Alkyds. *Transparency* - Semi Transparent to Semi Opaque. *Staining power* - slight.

Phthalocyanine Blue

PHTHALOCYANINE BLUE
Lightfastness
Watercolours II: Very Good
Oils I: Excellent
Acrylics I: Excellent
Gouache I: Excellent
Alkyds I: Excellent
PB 15

Phthalocyanine Blue, or Phthalo Blue as it is often called, is an extremely intense, very transparent, deep green-blue.

Although very versatile when handled with care, it can quickly stamp its mark on a painting unless used in moderation.

A powerful colour, it will quickly influence others during mixing and will stain the paper as a watercolour.

The main drawback to this factor is that mistakes cannot easily be rectified.

It will not only stain paper but may also gradually stain subsequent paint layers when used in any media.

Although it needs to be used with care, it is highly valued for its strength and transparency.

This latter factor being very important to many painters, particularly watercolourists and those who prefer to mix by glazing.

When applied heavily it can take on a slight metallic sheen, although not to the same extent as Prussian Blue.

Marketed under various names, Phthalocyanine Blue. Phthalo Blue, Thalo Blue, Monestial Blue, Winsor Blue, Rembrandt Blue, Cyanin Blue-and the list goes on.

It is also to be found in very many mixed colours, where it is often let down with rather large amounts of filler. Such colours are easily avoided.

Various types are in use, PB15, PB15:1, PB15:2 etc. The main difference between them is a slight colour shift. All are equally lightfast

You might also come across Phthalocyanine Blue PB 16. A reliable pigment which was given an ASTM rating of I: Excellent in both oils and acrylics.

Recommended

Mixing tips

With the addition of white the colour becomes very close to Cerulean Blue. Many imitation Cerulean Blues are, in fact, produced this way.

A range of very vivid greens will result when mixed with a green- yellow such as Hansa Yellow Light.

For extremely transparent, and often very subtle, blue greens, mix with either Phthalocyanine Green or Viridian.

Technical information: *Common Name* - Phthalocyanine Blue. *Colour Index Name* - PB 15 - 15:1 etc. *Colour Index Number* 74160 - 74160:1 etc. *Chemical Class* - Copper Phthalocyanine Blue. A*STM Lightfast rating* - Watercolour, II: Very good, oils, alkyds, acrylics and gouache tested I: Excellent. *Transparency* - Transparent. *Staining power* - high. *Drying* -An average drier forming a hard, durable film as an oil paint. Average oil content.

Prussian Blue

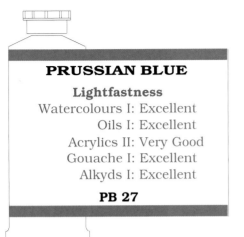

PRUSSIAN BLUE

Lightfastness
Watercolours I: Excellent
Oils I: Excellent
Acrylics II: Very Good
Gouache I: Excellent
Alkyds I: Excellent

PB 27

Prussian Blue was discovered in the early 1700s An event considered to be the beginning of the era of modern pigments.

A deep, very transparent, vibrant green-blue. It is a powerful hue which must be handled with great care or it will quickly dominate other colours.

Its high staining power must also be taken into consideration as it tends to stain any support and possibly subsequent paint layers.

These factors alone should not deter its use as they are manageable.

Other limitations, however, should be taken into account.

Although rated highly as far as fastness to light is concerned, it does have a rather troubled history.

It has often been reported that the colour can move towards brown and that it can fade in thin layers, particularly if mixed with white.

The colour returns to blue as a watercolour if it is then kept in the dark for a time.

Prussian Blue is avoided by many artists because it tends to take on a 'bronze' metallic sheen, particularly after heavy application.

In oils it tends to wrinkle in heavy applications due to its high oil content. Avoid adding further oil if using this colour.

The main reason for its gradual demise however, is because we now have Phthalocyanine Blue, a colour which is very similar in hue and transparency but superior in all other respects.

As you would certainly not need both colours, I suggest that you select Phthalo Blue if you require an intense, transparent green-blue.

Not Recommended

as a superior alternative exists

Mixing tips

Being a very definite green-blue, of great transparency, it will give clear, vibrant blue greens when combined with either Viridian or Phthalo Green. The mixing complementary (for darkening purposes) is a red-orange.

Technical information: *Common Name* - Prussian Blue or Milori Blue. *Colour Index Name* - PB 27. *Colour Index Number* 775100. *Chemical Class* - Ferri-Ammonium Ferrocyanide. *ASTM Lightfast rating* - Watercolour, oils, alkyds, and gouache I: Excellent, acrylics II: Very good. *Transparency* - Transparent. *Staining power* - high. *Drying* -A quick drier forming a hard film as an oil paint. High oil content.

Ultramarine Blue

ULTRAMARINE BLUE

Lightfastness

Watercolours I: Excellent

Oils I: Excellent

Acrylics I: Excellent

Gouache I: Excellent

Alkyds I: Excellent

PB 29

Genuine Ultramarine was produced from a semi-precious stone. Its preparation was difficult and very time consuming. The inexpensive, modern version is almost identical in every way.

A well made Ultramarine Blue is essential if the full range from a limited palette is to be achieved.

It is the only true violet-blue available and, as such, is the only blue able to contribute towards bright violets.

It will also play a very important part in colour mixing in general.

The pigment was originally produced from Lapis Lazuli, a semi-precious stone imported from Afghanistan.

Genuine Ultramarine was an exceedingly expensive pigment and, as such, was out of the reach of almost all artists who were not working on a commission (usually for the Church).

The invention of artificial Ultramarine by the Frenchman Monsieur J.B. Guimet in the early 1800s was a major breakthrough. We still owe much to him.

A bright, transparent violet blue with good tinting strength and absolutely lightfast.

Genuine Ultramarine is still manufactured, but on a tiny scale. Do not hanker after the pigment as it is almost identical in colour and chemical composition to the modern synthetic version. It is also very expensive.

Modern Ultramarine is available from light to dark and sold as Ultramarine or French Ultramarine.

Check the transparency (possibly of versions held by fellow painters) when deciding on a purchase. If the colour is not very clear in thin applications, choose again as it will probably contain an excess of filler. Fortunately this is not common.

An indispensable and inexpensive colour for all - round application.

Recommended

Mixing tips

A transparent violet-blue, which gives clear, bright violets with a quality violet-red such as Quinacridone Violet.

Semi-transparent mid greens with Hansa Yellow Light.

Semi-opaque dull greens with Cadmium Yellow Pale.

Darkens beautifully, whilst retaining its transparency, with Burnt Sienna.

Technical information: *Common Name* - Ultramarine Blue. *Colour Index Name* - PB 29. *Colour Index Number* 77007. *Chemical Class* - Complex Silicate of Sodium & Aluminum with Sulphur. *ASTM Lightfast rating* - Watercolour, oils, alkyds, gouache and acrylics I: Excellent. *Transparency* - Semi Transparent to transparent. *Staining power* - slight. *Drying* -Medium to slow drier forming a rather hard, brittle film as an oil paint. Medium to high oil content.

Miscellaneous blues

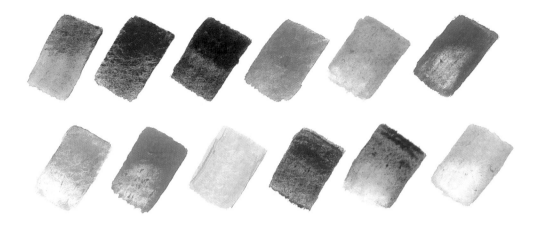

The majority of fancy or trade named blues on the market, in all media, are standard blue pigments such as Phthalocyanine Blue or Ultramarine Blue. Mixed blues are usually produced from such standards with the occasional addition of white or a green.

Whereas many yellows, oranges and reds sold under fancy or trade names are mixes of inferior pigments, the majority of blues falling under this description are standard but renamed colours.

As such (apart from the rare exception), they are reliable.

One of the favourites for the renaming ceremony is Phthalocyanine Blue. This excellent colour is sold under a wide range of names such as Brilliant Blue, Cyanin Blue, Helio Blue, Hoggar Blue, Hortensia Blue and Winsor Blue etc.

A more authentic name for Phthalocyanine Blue is Monestial Blue as the pigment was first offered as Monastral Blue in 1935.

Otherwise it is a case of manufacturers wishing to add yet another colour or two to their range. Or perhaps they feel that most artists are unable to handle words of more than two syllables. Is Phthalocyanine that hard a word to master?

I feel that it would be a giant leap forward if all fancy and trade names were dropped when describing a single pigment - and the common name used instead. Artists would identify the name and select accordingly, instead of having to wade through a mass of imaginative but meaningless names.

Prussian Blue comes in for more of the same treatment, being called anything from Antwerp Blue to Paris Blue. Antwerp Blue, incidentally, was at one time the name used to market Prussian Blue to which a large amount of filler had been added.

The colour sold as 'Permanent Blue' is usually Ultramarine Blue.

Various mixed blues are also on offer, these can be anything from Cerulean Blue and Cobalt Blue to Prussian and Phthalocyanine Blue. White is occasionally included in such mixes and sometimes a touch of Phthalocyanine Green.

They are reliable mixes in the main, but add quite unnecessary confusion! A confusion which, it would seem, has been deliberately built in.

How can it be otherwise when one company sells Phthalocyanine Blue under a trade name and also markets the same pigmented colour as 'Intense Blue', whilst another offers Ultramarine Blue under its own name as well as under 'Permanent Blue'?

To add to the confusion, entirely unsuitable (in fact, quite appalling) blues such as PB1 Victoria Blue, PB24 Fugitive Peacock Blue or PB66 Indigo Blue, find their way into the occasional mix, particularly in gouache or watercolours.

However, if you are aware of what you are buying you will not go far wrong.

Blue pigments to choose or avoid

The following pigments have not all been subjected to ASTM testing. Where they have not, I am offering guidance based on other independent testing as well as my own.

Reliable pigments - all have been subjected to vigorous testing.

PB15 Phthalocyanine Blue (PB15:1 etc.) - tested I: Excellent in oils, alkyds, acrylic and gouache. Rated II: Very Good as a watercolour.

PB17:1 Phthalocyanine Blue Lake - the only results available are II: Very Good in gouache. This would suggest it will be reliable in other media, but caution is advised as a watercolour.

PB22 Indanthrone Blue - tested ASTM I: Excellent in oils and acrylics.

PB27 Prussian Blue - tested ASTM I: Excellent in watercolour, oils, alkyds and gouache. Tested II: Very Good as an acrylic.

PB28 Cobalt Blue - tested I: Excellent in all media.

PB29 Ultramarine Blue - tested I: Excellent in all media.

PB35 Cerulean Blue - tested ASTM I: Excellent in watercolours, oils, acrylics and gouache.

PB36 Cerulean Blue, Chromium - tested ASTM I: Excellent in watercolours, oils and acrylics.

PB60 Indanthrone Blue - tested ASTM I: Excellent in oils and acrylics and II: Very good in own testing as a watercolour.

PB33 Manganese Blue - ASTM tested I: Excellent in watercolours, oils, acrylics and gouache. Please see notes on page 70.

Most unsuitable for artistic use - poor to very poor lightfastness.
Certain of the following might prove reliable in oils, acrylics or alkyd but all have failed convincingly in other areas. Why take the chance of using them?

PB1 Victoria Pure Blue - failed ASTM testing as a gouache V: (Will bleach very quickly). Also failed our own testing as a watercolour.

PB24 Fugitive Peacock Blue - failed our own testing as a watercolour. Bleached back to the white paper in a short time. Also has a very poor reputation.

PB66 Indigo Blue - failed our testing in a dramatic fashion. Has a poor reputation.

Introduction to greens

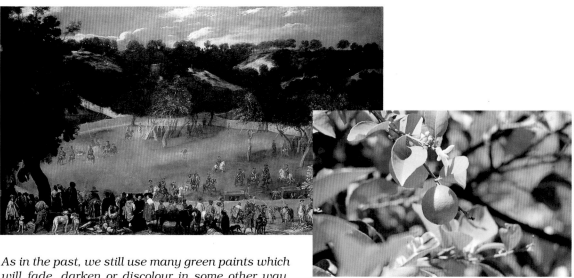

As in the past, we still use many green paints which will fade, darken or discolour in some other way. However, we no longer have the excuse that only a limited number of lightfast green pigments are available.

Philip IV hunting wild boars by Diego Velázquez. Courtesy the National Gallery, London.

The vast range of greens presented by nature to the realist painter cannot be produced without a clear understanding of colour mixing. The purchase and use of pre-mixed greens discourages mixing and can only lead to limited work.

Many of the dull, dark browns which are often admired on earlier paintings actually started life as rich, vibrant greens.

The blue trees on many a Renaissance painting were also once green as were many of the dull brown yellows in evidence.

It was once a constant struggle to find green pigments which did not deteriorate rapidly. Verdigris, the same colour which occurs on the copper roofs of many a cathedral, was, for many, the only bright green available.

It was susceptible to moisture, incompatible with many other pigments and blackened by the gases of the atmosphere.

Genuine Emerald Green not only darkened on exposure to the atmosphere but was so poisonous that it affected many artists by making them very sick or even causing death.

We now have at our disposal a range of very reliable greens, offering considerable choice over hue, transparency and intensity.

So why do we also have to suffer the inferior greens which manufacturers still quietly slip into their colour ranges? Greens which they *know* will fade or darken within a very short time. 'Demand' they tell us, is the reason. Artists 'demand' such colours.

Could it be that the true reason is that such unworthy paints, which are often cheap industrial colorants, can be sold to the unwary?

When one considers the situation fully, it is surprising that there has not been a severe backlash from artists worldwide against some of the practices of so many modern colormen.

Rely only on your own judgement, backed by a knowledge of which pigments are reliable, and you will be amongst the few artists who do not have a paint box stuffed with greens which will eventually ruin their work.

This will happen in much the same way as the work of many an earlier artist was ruined. The difference is, we no longer have an excuse.

Chrome Green

CHROME GREEN

Lightfastness

This is impossible to give as a variety of pigments are employed.

The Colour Index name varies

Chrome Green is yet another name from the past, used to sell a rather mixed bag of pigments.

The colour originally sold under this name was a mix of Chrome Yellow and Prussian Blue. It was a rather disastrous substance as the yellow invariably darkened, ruining the original colour.

Today the name is used to sell a variety of pre-mixed greens. Some of these will be lightfast and others not.

It is ironical that a name which at one time was used for a colour known to be inferior, has been retained by modern colormen.

Without the ability to decide on whether or not the pigments used are reliable,

purchasing such a colour is very much a game of chance.

I trust that this book will enable you to choose your colours for sound reasons. Let others be guided by the confusion of colour names and hype.

You will come across combinations such as PB15 Phthalocyanine Blue and PY3 Arylide Yellow 10G (Hansa Yellow Light).

The colour will be lightfast but so easily mixed on the palette.

Not only can you mix the particular shade offered in the tube with ease, but very many others of the same colour type.

Be wary of the common combination PB15 Phthalo Blue and PY1 Arylide Yellow

G. The yellow will almost certainly fade, causing the green to move towards blue.

I feel that there is a most definite need to check the ingredients before making any purchase.

In the first mix, the yellow was PY3 Arylide Yellow 10G, in the second, PY1 Arylide Yellow G. The two are easily confused, but the difference in reliability is dramatic.

I hope that you will feel it worth your time to take into account such detail when deciding on the colours to select.

I would suggest that you leave all versions of this colour, Pale, Standard and Deep, well alone.

Not Recommended

Mixing tips

The colour offered under this name varies considerably, from very yellow - greens in the 'Pale' version to deep blue greens in the 'Deep'. In fact, think of a green and it will be described as Chrome Green somewhere or other.

Because of the wide diversity of hue I cannot offer mixing tips other than to say that

the skills required to mix a vast range of greens can be easily mastered.

Technical information: *The details will vary depending on the actual ingredients used.*

Chromium Oxide Green

CHROMIUM OXIDE GREEN
Lightfastness
Watercolours I: Excellent
Oils I: Excellent
Acrylics I: Excellent
Gouache I: Excellent
Alkyds not tested but will almost certainly be lightfast.
PG 17

A solid, reliable colour that has a place on many an artist's palette.

In use since around 1862 it is a pigment with a well deserved place alongside more modern colorants.

A dull, yellow to mid green which is noted for its opacity. An opacity which can be very useful when covering previous work.

It has a very good reputation and is absolutely lightfast in all media in which it has been tested.

It is not affected by light, acids, weak alkalis or heat.

Being quite high in tinting strength it has a very definite part to play in colour mixing.

In this respect it will soften, cool and dull many colours, working very well with opaque blues and yellows.

If you value the dulled soft green of Terre Verte (page 84), but wish for better handling qualities, I would suggest this colour, with possibly a touch of Cerulean Blue.

Applied thinly it will imitate Terre Verte quite closely and be particularly useful as an under colour when glazing.

Related to Viridian, it is sometimes offered as Oxide of Chromium *Opaque* to distinguish it from Oxide of Chromium *Transparent*, an alternative name for Viridian.

The colour hardly varies between manufacturers.

An excellent, inexpensive, dull opaque green.

Recommended

Mixing tips

When mixed with Cerulean Blue (an opaque green-blue), it will give soft, muted blue greens of great subtlety.

Similar (but semi-transparent) greens can be mixed from Cadmium Yellow Light (opaque) and Ultramarine Blue (transparent).

If the colour is too bright, try adding a touch of Cadmium Red Light to dull it.

Alternatively mix Cadmium Yellow Light with Cerulean Blue (both opaque). Again use a touch of Cadmium Red Light to darken and to dull.

This will give a colour equally opaque to Chromium Oxide Green.

Technical information: *Common Name* - Chromium Oxide Green. *Colour Index Name* - PG 17. *Colour Index Number* 77288. *Chemical Class* - Anhydrous Chromium Sesquioxide. *ASTM Lightfast rating* - Watercolour, oils, gouache and acrylics I: Excellent, not tested in alkyds. *Transparency* - Opaque. *Drying* -An average drier forming a fairly hard but flexible film as an oil paint. Low oil content.

Cobalt Green

COBALT GREEN
Lightfastness
Watercolours I: Excellent
Oils I: Excellent
Acrylics I: Excellent
Gouache I: Excellent
Alkyds not tested but will almost
certainly be lightfast.
PG 19

Introduced in 1835, this was, at one time, a very popular and fashionable colour.

It has declined in use steady since the turn of the century.

A rather dull, or neutralised, delicate blue-green which is easily duplicated on the palette.

The pigment lacks body, a defect apparent in whatever medium it is prepared. Unless additives have been introduced to 'beef' the paint up.

It not only lacks body but is also a very weak colour which is easily swamped by others in a mix.

The genuine pigment is semi-transparent to semi-opaque.

Its lack of body, relatively high cost and low tinting strength has led to its decline as an artists colour.

It is still available but fewer artists are using it.

A high percentage of 'Cobalt Greens' on the market have not even been near the genuine pigment.

The following, in various combinations can be found in many imitations: Viridian, Phthalocyanine Green. Cerulean Blue, Light Green Oxide and Cobalt Blue etc.

Few of these imitations are identified as such, being sold simply as Cobalt Green (Light, Medium or Dark).

Not recommended

unless you are happy with the limitations.

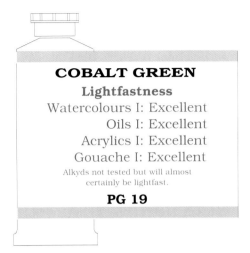

Mixing tips

A slightly bluish green (the genuine article that is, as imitations vary considerably), it can be darkened successfully by an orange-red such as Cadmium Red Light.

Do bear in mind with such a mix that the red will be far stronger and more opaque than the green.

Technical information: *Common Name* - Cobalt Green. *Colour Index Name* - PG 19. *Colour Index Number* 77335. *Chemical Class* - Oxides of Cobalt and Zinc. *ASTM Lightfast rating* - Watercolour, oils, gouache and acrylics I: Excellent, not yet tested in alkyds. *Transparency* - Semi transparent to semi-opaque. *Drying* An average drier forming a fairly hard but flexible film as an oil paint. Medium to low oil content.

Emerald

In earlier times the trade mark of the artist would almost certainly have been a sickly complexion, so toxic were many of the pigments in use.

One of the most dangerous must surely have been Emerald Green.

In use since the early 1800s, it contained a high level of arsenic.

The same material as that offered to and used by artists has also been employed to control locusts and prevent algae growth on ships' hulls.

It not only controlled locusts but also artists as many were made very sick or died.

It is even thought that Napoleon might have died as a result of breathing dust from wallpaper coloured by Emerald. Many others certainly did.

Added to its poor reputation, it also darkened on exposure to the atmosphere, when in contact with certain metals and when mixed with colours such as Ultramarine Blue and Cadmium Yellow.

Artists became so wary of the pigment that the colormen went to great lengths to disguise its use behind fancy titles.

At one time, for example, up to fifty different names were in use in Germany to sell this substance. It was a similar story elsewhere.

Little has changed in this respect, now fancy names are commonly used to disguise colours which will fade or darken.

The genuine pigment is thankfully obsolete but the name has been retained to market a range of bright mid greens.

These are most commonly based on Phthalocyanine Green and PY3 Arylide Yellow, with the occasional inclusion of a white. As such, the colour will usually be both lightfast and easily mixed.

For a name with such a disastrous history to have survived, and still be in general use, does show what a strange world we live in.

Not recommended

as it is easily mixed

A mix of Cerulean Blue and a green-yellow such as PY 3 Hansa Yellow Light or PY 35 Cadmium Lemon Yellow will give a similar colour to those commercially available. To match some versions add a little white, with others mix in a touch of Cadmium Red Light to dull the colour.

If anything, such mixes will be brighter when mixed on the palette that when pre-mixed by the manufacturer. It will also mean one less colour to purchase and hold.

Add a small amount of Cadmium red Light to dull the colour, if required. As with so many pre-mixed colours, this is only one amongst the many thousands of greens which can be mixed with ease.

Technical information: *The details will vary depending on the actual ingredients used.*

Hooker's Green

HOOKER'S GREEN

Lightfastness
This is impossible to give as a variety of pigments are employed.

The Colour Index Name varies

I find it interesting to trace the history of colour names and wonder sometimes how certain of them have survived to the present day.

In particular I find it rather unusual that so many names which were once used to sell colours despised by the artist are still around, still in use, but employed to sell superior products.

However, this is not always the case as the names of certain inferior substances from the past are used to sell equally substandard colours nowadays.

Hooker's Green is a very good example of this. It was originally a very inferior watercolour produced from a mix of Prussian Blue and Gamboge.

The yellow tended to fade and the original green gradually turned blue.

This disastrous combination has been replaced by equally poor mixtures.

It would seem that the idea is to put together almost any combination which will give a mid to deep green, as long as the final result is unsuitable for artistic use.

Apart from the rare exception, Hooker's Green (Light, Medium or Dark), will deteriorate rapidly on exposure to light, in all media.

Sometimes the yellow will fade turning the colour bluish green. At others the blue will gradually disappear.

Sometimes they both will, it can be that versatile!

An actual Hooker's Green pigment now exists, PG8 Hooker's Green. It has failed all tests of which I have record. As a watercolour it was rated ASTM IV : Will fade rapidly.

Do not be mislead into thinking that any of the mixed Hooker's Greens are unique in any way. All are easily produced using reliable pigments.

Not Recommended

Mixing tips

As I have tried to show in my book 'Blue and Yellow Don't Make Green', with two carefully selected blues and two equally well chosen yellows, it is possible to mix a very wide range of greens.

If either a violet-red or an orange-red is then added to darken, a vast range of greens can be mixed with ease.

You will certainly be able to duplicate any of the 'Hookers Greens' on offer. But with lightfast pigments and during the course of the painting.

Technical information: *The details will vary depending on the actual ingredients used.*

Olive Green

OLIVE GREEN

Lightfastness

This is impossible to give as a variety of pigments are employed.

The Colour Index Name varies

Olive Green is a name used to describe any cocktail of pigments which will give a dull, brownish yellow - green.

It should not even be considered a convenience colour, as reliable pigments are very rarely used.

Good old fugitive PY1 Arylide Yellow abounds, as do the unreliable PR 83 Rose Madder Alizarin and PG8 Hookers Green.

You can find versions which are lightfast and will not spoil your work, but you will usually have to seek them out. But why bother? Such colours are easily mixed.

This is yet another dumping ground for cheap, inferior industrial colorants.

Not Recommended

Sap Green

SAP GREEN

Lightfastness

This is impossible to give as a variety of pigments are employed.

The Colour Index Name varies

Sap Green was originally produced from the berries of the Buckthorn bush. It was, and remains, an unreliable dull green.

The name Sap Green was originally used for a very fugitive colour produced from the berries of the Buckthorn bush. It was usually prepared without a binder as the juice was naturally very sticky.

It was allowed to thicken and then often kept in animal bladders. Nowadays it is, as with Hookers Green and Olive Green, used to sell any mix which will give a dull green. Of 21 watercolours examined, only 5 were found to be reliable.

Usually a disastrous substance well worth avoiding. Such dull greens can easily be mixed from Ultramarine Blue and Cadmium Yellow Light, perhaps with a touch of violet-red.

Not Recommended

82

Phthalocyanine Green

PHTHALOCYANINE GREEN

Lightfastness
Watercolours I: Excellent
Oils I: Excellent
Acrylics I: Excellent
Gouache I: Excellent
Alkyds I: Excellent

PG 7

It is most depressing to have to describe so many pre-mixed greens which are a disgrace to the profession of colour manufacturer.

So it is with some pleasure that I come to Phthalocyanine Green.

A 'clean' vibrant blue-green produced by the further processing of Phthalocyanine Blue.

Noted for its very high strength and purity of colour, it must be managed with some care as it can quickly dominate a painting. The fact that it is a powerful stainer must also be taken into account.

A well made version will be extremely transparent and of great value in washes and when mixing by glazing.

It closely resembles Viridian in colour, but is, if anything, even more intense. It is also often slightly darker.

This excellent pigment, which is very resistant to light, is sold under a wide range of fancy but usually meaningless names. It would help if this practice were to cease, then the artist might be in a better position to choose. Apart from the sillier names, it is also sold as Monestial Green, Thalo Green, Phalo Green and Winsor Green.

You might come across the use of Phthalocyanine Green PG36. A member of the same family, it tends to be yellower in hue. It is as lightfast as PG7.

Recommended

When choosing a mixing partner, the transparency of both colours should also be taken into account.

Mixing tips

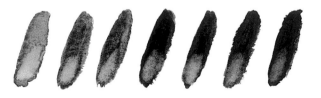

When a transparent complementary pair are mixed, the results remain transparent throughout and the coloured greys are very dark.

Quinacridone Violet makes an ideal mixing partner to Phthalocyanine Green, not only in hue but also in transparency.

Technical information: *Common Name* - Phthalocyanine Green. *Colour Index Name* - PG 36. *Colour Index Number* 74265. *Chemical Class* - Chlorinated & Brominated Phthalocyanine. *ASTM Lightfast rating* - Watercolour, oils, gouache, acrylics and alkyds I: Excellent. *Transparency* - Transparent. *Staining power* - high. *Drying* - Slow to medium drier when made up into an oil paint, forming a fairly hard, durable film. Average oil content.

Terre Verte (Green Earth)

TERRE VERTE
or **GREEN EARTH**
Lightfastness
Watercolours I: Excellent (own test)
Oils I: Excellent
Acrylics I: Excellent
Gouache I: Excellent
Alkyds I: Excellent
PG 23

An ancient pigment still with us is Terre Verte or Green Earth. A coloured clay, dug from various deposits around the world.

In use since pre-classical times, it has been found on Pompeiian wall paintings and ancient works from India.

It was a popular pigment for underpainting, priming wood panels, as a base for gilding, a tinter for parchment and a base colour for fresco work. So much was used that the known quality deposits were all dug up and used long ago. Today we are left with inferior green clays which are often strengthened in colour with dyes or other pigments.

In fact we are presented with a rather mixed bag of colorants sold under this name.

Genuine Green Earth is offered by some, Green Earth strengthened by dyes and additional pigments by others, and the rear is brought up by a rather motley collection of imitation mixes.

Such imitations might be a combination of Phthalo Green and Raw Umber, Burnt Sienna and Ivory black or Chromium Oxide Green, Raw Umber and a black. Such mixes are, of course, easily duplicated on the palette from colours known to be reliable.

The genuine substance is another matter. Whether strengthened with other colorants or not, Green Earth must be one of the most unpleasant paints to handle as its physical properties do not lend themselves to paint making.

It tends to brush out very poorly and has a soapy, gelatinous texture.

Not recommended

At one time Green Earth was commonly used for under painting, being particularly employed for the under layers of flesh tones. As this part-finished work by Michelangelo shows, it was used to give subtlety to flesh tones when mixing by glazing, the dull green influencing the subsequent thin layers of warm ochre.

A dull, weak, fairly transparent green which varies

Mixing tips

considerably in colour, from a dull yellowish - green, to blueish grey-green to a brown olive-green. Many of examples on the market are easily duplicated by a thin layer of Chromium Oxide Green, with possibly a touch of Cerulean Blue and/or Raw Umber.

Illustration: Madonna with Child with the Infant Baptist and Angels. Ascribed to Michelangelo. Courtesy the National Gallery, London.

Technical information: *Common Name* - Terre Verte or Green Earth. *Colour Index Name* - PG 23. *Colour Index Number* 77009. *Chemical Class* - Ferrous Silicate with Clay, Inorganic. *ASTM Lightfast rating* - Oils, gouache, acrylics and alkyds I: Excellent, not yet tested as a watercolour. *Transparency* - Semi transparent to transparent. *Drying* - A medium to slow drier forming a soft flexible film as an oil paint. Medium to high oil content.

Viridian

VIRIDIAN

Lightfastness
Watercolours I: Excellent
Oils I: Excellent
Gouache I: Excellent
Alkyds I: Excellent
Acrylics not tested but will almost certainly be lightfast.
PG 18

Compatible with all other pigments, lightfast and unaffected by dilute acids and alkalis, Viridian is an excellent all - round pigment.

A bright, very transparent green-blue, it is very similar in hue and transparency to Phthalocyanine Green. Like that colour it is also highly prized as a glazing hue, giving very clear layers when applied thinly.

It takes on a very dark, 'heavy' appearance when applied at all thickly.

Related to Chromium Oxide Green, it is sometimes offered as Oxide of Chromium *Transparent*, to distinguish it from Oxide of Chromium *Opaque*. (See page 78).

The better qualities are smooth and handle well, however quite a few examples on the market tend to be a little gritty and do not brush out well. This can be particularly noticeable in watercolours, where the finished paint can also be rather pasty in texture.

If you find a well produced version you will have a first class transparent green.

Again, as is the case with Phthalocyanine Green, it is a vibrant, staining colour which needs to be handled with some care.

Although I would personally choose Phthalocyanine Green over Viridian because of its (usually) better handling qualities, many prefer the slightly softer, less intense, colour of Viridian.

Recommended

Mixing tips

As with Phthalocyanine Green, the ideal mixing partner is a clear, strong, violet-red such as Quinacridone Violet.

Mixed with the equally transparent Phthalocyanine Blue, a series of exceedingly transparent blue greens can be produced with ease.

Such hues, which can be very subtle, are highly valued by many artists. Particularly for the depiction of water under certain light conditions.

Technical information: *Common Name* - Viridian. *Colour Index Name* - PG 18. *Colour Index Number* 77289. *Chemical Class* - Hydrous Chromium Sequioxide. *ASTM Lightfast rating* - Watercolour, oils, gouache and alkyds I: Excellent, not yet tested as an acrylic. *Transparency* - Transparent. *Staining power* - high. *Drying* - A slow to average drier forming a fairly hard but flexible film as an oil paint. High oil content.

Miscellaneous greens

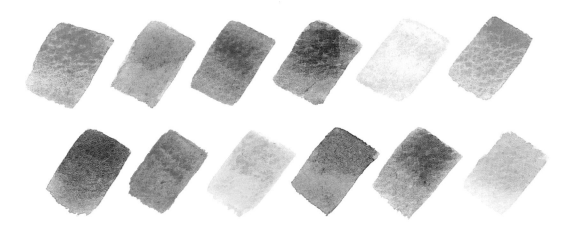

Many miscellaneous greens on the market, in all media, are standard greens such as Phthalocyanine Green, Viridian or Chromium Oxide Green. Mixed greens often contain ingredients which will spoil the colour on exposure to light. Such exposure need only be over a relatively short time. Be very wary when purchasing any green if the pigments used cannot be easily identified.

Because the majority of painters rely on the now defunct Three Primary System, they experience a great deal of trouble when it comes to mixing a wide range of greens.

To overcome these problems many use standard greens as they come from the tube or purchase pre-mixed greens sold under enticing but usually quite meaningless names.

Such greens are collected and valued as if they were in some way unique colours and necessary for a full palette.

In fact the opposite is the case. With few exceptions, greens sold under fancy or trade names are simple mixes which, if anything, can inhibit an artist's work.

Many of the pre-mixed greens on offer contain pigments which will cause the colour to deteriorate one way or another. Perhaps the yellow will fade, moving the colour towards blue, or the blue will gradually disappear causing the green to become yellower, perhaps they will both fade or darken at the same time.

Be on the look out for such inferior yellow pigments as PY100 Tartrazine Lake and PY1 Arylide Yellow, unsuitable blues such as PB1 Victoria Blue and unreliable greens such as PG1 Brilliant Green, PG2 Permanent Green,

PG8 Hooker's Green and PG12 Green.

To add to the muddle, well known standard greens such as Phthalocyanine Green, Viridian and Chromium Oxide Green come in for the renaming treatment.

Phthalocyanine Green, for example, is sold under names ranging from Armor Green, to Cyanin Green through to Helio, Monestial and Winsor Green.

Be wary of companies who market both the standard colour as well as the same colour renamed. Buy them both if you are a collector, but otherwise ask yourself why such practices exist.

You should also be aware of names which promise what they do not deliver. A high percentage of 'Permanent Greens', for example, in all media, contain pigments which will cause them to deteriorate rapidly.

Personally I would not give any of the pre-mixed greens a second glance. If you were to purchase each and every one on the market you would have a tiny fraction of the vast range on offer to the artist with colour mixing skills.

With two selected yellows, two blues and two reds it is an easy task to mix reliable greens by the tens of thousands.

Green pigments to choose or avoid

The following pigments have not all been subjected to ASTM testing. Where they have not, I am offering guidance based on other independent testing as well as my own.

Reliable pigments - all have been subjected to vigorous testing.

PG7 Phthalocyanine Green - tested ASTM I: Excellent in all media.

PG10 Green Gold (option of adding name Nickel Azo Yellow) - tested ASTM I: Excellent in oils and acrylics. Own test as a watercolour rated II: Very Good.

PG17 Chromium Oxide Green - tested ASTM I: Excellent in watercolours, oils, acrylics and gouache.

PG18 Viridian - tested ASTM I: Excellent in watercolours, oils, alkyds and gouache.

PG19 Cobalt Green - tested ASTM I: Excellent in oils, acrylics, alkyds and gouache.

PG23 Green Earth - tested ASTM I: Excellent in watercolours, oils, acrylics and gouache. Own test in watercolours also I: Excellent.

PG36 Phthalocyanine Green - ASTM tested I: Excellent in oils and acrylics. Own testing also rated 1.

PG50 Light Green Oxide - tested ASTM I: Excellent in oils, and acrylics. II: Very Good in own test.

Most unsuitable for artistic use - poor to very poor lightfastness.
Certain of the following might prove reliable in oils, acrylics or alkyd but all have failed convincingly in other areas. Why take the chance of using them?

PG1 Brilliant Green - darkened rapidly during own testing. Most unreliable.

PG2 Permanent Green - darkened very quickly on exposure to light during our own testing. Has a very poor reputation.

PG8 Hooker's Green - tested ASTM IV (Will fade rapidly) as a watercolour and III (Can fade rapidly) as a gouache. Also failed own testing in other media.

PG12 Green - failed ASTM testing as a watercolour with a rating of IV: Will fade rapidly.

Introduction to browns

Naturally occurring coloured earths provide us with superb lightfast browns. Roasting extends the range on offer.

The earth colours remain the most reliable, inexpensive and inert colours of the palette. Used by the early cave painters, they still offer excellent service.

The earth colours vary depending on the amount of iron oxide and other minerals that they contain. Ochres contain relatively little iron oxide, the principal colouring agent.

As the iron oxide content increases the Ochres move into the Siennas. An increase in the Manganese Oxide content of the Siennas leads onto the Umbers.

Heat will further modify these colours, giving us Burnt Sienna, Burnt Umber and Light Red.

Although such colours are readily available, artificial versions have been with us for some time. The Mars colours, Mars Yellow, Red and Brown and other synthetic iron oxides such as Venetian Red have their part to play.

Some exotic substances have been put to use in the past to increase the range offered by the earths. At one time, Egyptian Mummies were ground-up to produce a shadowy, dark brown.

Although I have sighted an artists' catalogue describing the 'fleshy part of the leg' as the best, when the use of ground-up corpses was made public, artists denied knowledge of the actual substance that they had been using. It was used until the 1800s, so you never know quite what part of who is looking down at you from certain earlier works.

Bistre, a brown made by boiling wood soot (which must have been a messy business), was replaced during the 1700s by Sepia.

The dried ink sac of the cuttle fish or squid gave the original Sepia. The colour now sold under this name is usually a mixture of black and an earth colour.

The liquorice root gave another deep brown. Unfortunately it was so fugitive that it probably lasted longer when made into a confectionary.

Despite the excellent range of lightfast brown pigments available, the colormen cannot resist slipping in Van Dyke Brown, one of the most worthless pigments still in use.

It does have a nice, reassuring, traditional name though, which a lot of painters will fall for. But not you!

Brown Madder

BROWN MADDER

Lightfastness
This is impossible to give as a variety of pigments are employed.

The Colour Index Name varies

For whatever reason, manufacturers and presumably many painters, only feel comfortable with a wide range of colours, whether they are worth having or not.

Various pigments have to be mixed to produce such a wide range. Although these could all be lightfast (without affecting the actual colour range), this is often not the case.

Brown Madder, like so many other simple mixes, falls into the category of 'generally unsuitable for artistic use'.

Although reliable examples are on the market they are few and far between.

The majority are quite un-suitable as they are based on PR83:1 Alizarin Crimson. (Please see page 47).

Various browns, reds and yellows are added to this well known but unreliable red.

On exposure to light, most colours sold under this name will change in hue and also fade.

They will resist fading if applied thickly, but they then take on a very heavy, dark appearance.

In earlier times, this colour was produced by gently heating natural Alizarin, so it has always tended to fade. It was originally known as Alizarin Brown.

Depending on the actual mixture, this is usually a fairly transparent staining colour of low intensity.

As mentioned, you can find colours sold under this name which are permanent and suitable in every way.

Be wary though, as Burnt Sienna is also sold under this name, and you might not want two tubes of the same colour.

If you purchase a reliable example you will almost certainly be buying a colour which you could easily mix.

You will also be encouraging the continued use of a name which has become meaningless to all but certain manufacturers' accountants.

Not Recommended

Mixing tips

It is difficult to suggest a way to mix this colour from reliable paints as it varies so much, depending on the whim of the manufacturer, as indicated top right.

It also varies in transparency depending on the pigments employed in its manufacture.

As many examples are neutralised, or dulled violet reds, they can be matched by adding a touch of yellow-green to a reliable violet-red such as Quinacridone Violet.

Alternatively, add some of the same red to Burnt Sienna for the redder examples. Or why bother, mix such hues as you work without even thinking of this pointless colour.

Technical information: *The details will vary depending on the actual ingredients used.*

Burnt Sienna

BURNT SIENNA
Lightfastness
Watercolours I: Excellent
Oils I: Excellent
Acrylics I: Excellent
Gouache I: Excellent
Alkyds I: Excellent

PBr 7

We have inherited a variety of pigments from earlier artists and colour manufacturers, some dating back to antiquity. Many of these are quite worthless and should have been replaced long ago.

Certain of our inherited colours, however, are superb. Chief amongst these must surely be Burnt Sienna, a pigment long valued for its clean colour and transparency.

This latter factor is too often ignored by modern painters, who, rather than exploit the clarity of the colour to its fullest, often plaster it on in heavy layers, thinking of it as no more than a type of brown.

A moment's experimenting will show that thin applications will give a glowing neutral orange.

It was discovered long ago that Raw Sienna could be roasted to produce Burnt Sienna - a warm, rich colour which varies from a slightly yellow neutral orange to a reddish brown.

It should be borne in mind that this is an earth colour and as such will vary in hue and transparency. Not only will the base Raw Sienna vary but the degree of roasting will also affect the final colour.

For these reasons I suggest that you try every make which comes your way. Perhaps fellow artists have several varieties between them, if so ask for a tiny amount from each.

A quick wash will soon reveal the make with the greatest clarity and the colour which suits your work. It can be a mistake to simply accept the full colour range from any one particular manufacturer.

The only limitation here is when choosing acrylics, different makes should not be mixed as their formulations are rather complex.

Burnt Sienna does tend to darken over time in oils.

Recommended

Mixing tips

Exploit the clarity of this colour by selecting, where possible, other transparent colours as mixing partners.

Burnt Sienna neutralises very well with transparent Ultramarine Blue (please see page 73). They will darken each other efficiently and produce some valuable darks, approaching black.

It can be taken towards clear neutral red - oranges by mixing with Quinacridone Violet.

And semi-transparent, neutral yellow-oranges with a green-yellow such as Hansa Yellow Light.

Technical information: *Common Name* - Burnt Sienna. *Colour Index Name* - PBr 7. *Colour Index Number* 77492. *Chemical Class* - Calcined Natural Iron Oxide. *ASTM Lightfast rating* - Watercolour, oils, gouache, acrylics and alkyds I: Excellent. *Transparency* - Transparent. *Staining power* - medium. *Drying* - A fast to average drier forming a hard, fairly strong, durable film as an oil paint. Medium to high oil content.

Burnt Umber

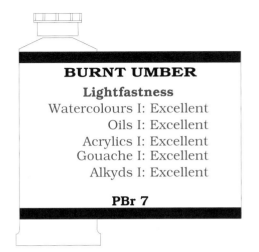

BURNT UMBER
Lightfastness
Watercolours I: Excellent
Oils I: Excellent
Acrylics I: Excellent
Gouache I: Excellent
Alkyds I: Excellent

PBr 7

It was discovered in antiquity that the earth colours could be darkened and altered through heating.

As with Burnt Sienna, this is another excellent pigment from the past.

In use since antiquity it came into widespread use from the early 1600s

It is produced by roasting Raw Umber until it has changed to the required hue, the final colour depending very much on the furnace operator.

It varies from a dark orange brown to a rich, dark reddish-brown.

A rich, fairly 'heavy' colour which is quite high in tinting strength and hiding power.

Although it will cover other colours quite well, it is reasonably transparent in thin applications, varying from semi-transparent to semi-opaque.

Its transparency is not only useful when glazing but makes it a popular colour for thin underpainting, where it can be used for the initial drawing and block work.

As with the other earth colours it is absolutely lightfast in all media.

In oils it can tend to darken with time due to the high oil content.

In lower grades it can be rather grainy, so seek out the best and try as many makes as possible before deciding.

Although this is an excellent all round, inexpensive colour, one or two paint manufacturers offer imitations.

It is possible to find a mix of Mars Red and Carbon Black sold as Burnt Umber.

Or Mars Yellow and Mars Black offered, not as 'Burnt Umber Hue' or 'Imitation', but as Burnt Umber.

Although such combinations are absolutely lightfast, and will normally handle well, they should not, to my mind be offered as the genuine article.

The use of black will always dull the colour and the final result is lacking in richness when compared to genuine Burnt Umber.

Recommended

The debate on the use of black continues. Personally I feel that it will always dull and 'dirty' any colour with which it is mixed and when used unmixed can be too harsh.

The ideal 'black' to my mind comes from a mix of either Burnt Sienna and Ultrama-

Mixing tips

rine Blue or Burnt Umber and Ultramarine, as shown here.

It is the ideal way to produce rich, deep, colourful darks.

Technical information: *Common Name* - Burnt Umber. *Colour Index Name* - PBr 7. *Colour Index Number* 77492. *Chemical Class* - Calcined Natural Iron Oxide containing Manganese. A*STM Lightfast rating* - Watercolour, oils, gouache, acrylics and alkyds I: Excellent. *Transparency* - Semi-opaque. *Staining power* - slight. *Drying* - A quick drier forming a tough, flexible film as an oil paint. Medium to high oil content.

Indian Red

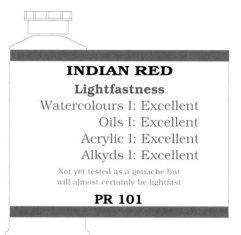

INDIAN RED

Lightfastness

Watercolours I: Excellent

Oils I: Excellent

Acrylic I: Excellent

Alkyds I: Excellent

Not yet tested as a gouache but
will almost certainly be lightfast

PR 101

Originally this colour was a naturally occurring red ochre, which was imported into Europe from India.

The name has been retained to describe another in the family of synthetic iron oxides.

The various PR101s - Mars Violet, Mars Red, Light or English Red Oxide, Venetian Red and Indian Red (all synthetic iron oxides), differ from each other only in colour, all are very close chemically.

Such differences in colour can be very slight so be careful not to purchase several colours similar in hue, particularly if you also use the natural earths.

Without a doubt it can be rather confusing, but if you take your time, examine as many examples as possible held by fellow artists and hold fewer rather than extra colours, you will not go far wrong.

Whereas Light or English Red and Venetian Red are usually similar in colour, so Mars Violet and Indian Red also carry similarities.

It would probably not be a good idea to hold both.

Indian Red covers other colours well but will give a reasonably clear wash.

An absolutely lightfast pigment.

Recommended

Mixing tips

When selecting a mixing partner this colour can usually be treated as a dull, or neutralised violet-red.

As such, it will darken and remain in character with a yellow-green. Because the basic colour can vary between manufacturers, being redder in some instances and moving slightly towards orange in others, you might have to experiment a little when mixing the yellow-green.

Technical information: *Common Name* - Indian Red. *Colour Index Name* - PR 101. *Colour Index Number* 77491. *Chemical Class* - Synthetic Red Iron Oxide (bluish hue). A*STM Lightfast rating* - Watercolour, oils and alkyds I: Excellent. Not yet tested as a gouache. *Transparency* - Semi-opaque. Forms a strong film. Medium oil content.

Light Red Oxide or English Red Oxide

LIGHT RED OXIDE or ENGLISH RED OXIDE

Lightfastness

Watercolours I: Excellent

Oils I: Excellent

Acrylic I: Excellent

Acrylic, alkyds and gouache not tested but will almost certainly be lightfast

PR 101

Another in the list of synthetic or artificial iron oxides and, as such, is a close cousin of colours such as Indian and Mars Red.

This group is distinguished by colour alone and there are many similarities. One manufacturer's version of this colour might be very close, or even identical in colour to another's Venetian Red.

To help in the selection process between one synthetic red-brown and another, I would suggest that you paint out a small area in a very thin layer of each colour that you could be interested in.

This will reveal the undercolour, which can be quite different from the mass colour.

You might find that three or four colours from this experiment might look fairly similar when painted out thickly, but the undercolour can vary from a salmon pink to a soft violet.

It is common for artists to select colours in an art shop simply by opening tubes and looking at the colour.

This, of course would be the same colour that presents itself in a thickly applied layer. It then often happens that when the purchased colour is applied thinly a different hue emerges.

Recommended

Mixing tips

As mentioned above, it will be a worth-while exercise to paint out a range of the synthetic iron oxides in order to study their undercolour.

This will give an indication of the direction to take when colour mixing. Perhaps add white to give a different, but also revealing, range of tints.

If you have already purchased a range of natural earths in addition to synthetic iron oxides, I would suggest a similar exercise encompassing them all.

You will learn much about your colours this way.

Technical information: *Common Name* - Light or English Red Oxide. *Colour Index Name* - PR 101. *Colour Index Number* 77491. *Chemical Class* - Synthetic Red Iron Oxide (yellowish hue). A*STM Lightfast rating* - Watercolour, acrylic and oils I: Excellent. Not yet tested in other media. *Transparency* - Semi-opaque. Medium oil content.

Light Red

LIGHT RED

Lightfastness

Watercolours I: Excellent

Oils I: Excellent

Acrylic I: Excellent

Alkyds and gouache not tested but
will almost certainly be lightfast

PR 102

In the past there was incredible confusion surrounding the naming of such rich orange browns.

Synthetic iron oxides were given the name of natural earth colours and vice versa. In addition, the full range of synthetic colours such as Indian Red, Mars Red and Venetian Red swapped colour names with each other on a regular basis.

Much of this confusion has been ended thanks to the work of the ASTM sub-committee on artists' paints.

Light Red was at one time the name used for either a roasted synthetic yellow or calcined neutrally occurring Yellow Ochre.

Some time ago it was agreed with the ASTM that manufacturers would henceforth confine the name to calcined Yellow Ochre - so that one has been sorted out - now to the next.

There is often confusion between Light Red and Light Red Oxide.

The differences are now straightforward. Light Red Oxide is a *synthetic* colour (please see previous page), Light Red is a roasted *natural* earth colour.

At the end of the day it will be better to try as many versions as possible of all the various colours (both natural and synthetic) and choose accordingly.

Perhaps friends who also paint will cooperate in this respect; as your local art shop will probably be less than interested in you opening and trying their colours.

As I have found, only so much can be done out of sight behind the paint stand.

Otherwise you could always make contact with a local art class or art group. It will be worth the trouble if you are choosing a permanent palette.

Light Red varies in colour depending on the decision of the furnace operator. It also varies from opaque to reasonably transparent and usually handles very well.

Recommended

Mixing tips

As this colour is essentially a neutral mid to red-orange, it will be worth experimenting with the various blues to decide on an ideal complementary mixing partner.

Technical information: *Common Name* - Light Red. *Colour Index Name* - PR 102. *Colour Index Number* 77492. *Chemical Class* - Calcined yellow Ochre. *ASTM Lightfast rating* - Watercolour, oils and acrylics I: Excellent, not yet tested in alkyds or gouache. *Transparency* - Opaque to semi-opaque. Forms a strong film.

Mars Brown

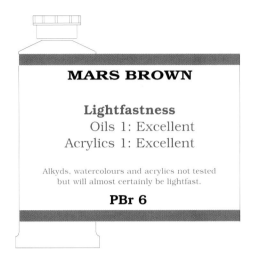

As has been mentioned elsewhere in this book, the Mars colours are synthetically produced versions of the naturally occurring iron oxides.

They have been in production since the mid 1800s and are in widespread use in various media.

Mars Brown is used by many artists as a substitute for natural colours such as Burnt Sienna.

The Mars colours are usu-ally chemically purer than the natural iron oxides, (which can contain a variety of impurities).

They are also more consistent in colour between batches, being artificially produced. However, they have not replaced the natural iron oxides.

Many artists find that the natural earths offer greater transparency and are usually softer in colour, the Mars col-ours sometimes tend towards harshness in comparison.

This is a useful colour which will find its place on many a palette. It is a reasonably strong colour with good covering power.

It varies somewhat in colour between makes and media, so choose with care if it appeals to you. Absolutely lightfast.

Recommended

Mixing tips

Mars Brown can be taken towards a colour resembling Raw Sienna by adding Mars Yellow or Cadmium Yellow Light. The result will not be as transparent as Raw Sienna.

Some very interesting reddish browns result when Cadmium Red Light is added. Such mixes cover previous work well as the Cadmium Red is opaque.

Mars Brown can be darkened, and still cover well, with the addition of a little Cerulean Blue. This is basically a blue/orange (complementaries) mix.

Technical information: *Common Name* - Mars Brown or Brown Iron Oxide. *Colour Index Name* - PBr 6. *Colour Index Number* 77499. *Chemical Class* - Synthetic Brown Iron Oxide or mixtures of synthetic iron oxides. A*STM Lightfast rating* - Oils and acrylics, 1: Excellent, not yet tested in alkyds, watercolour or acrylics. *Drying* - An average drier as an oil paint.

Mars Red

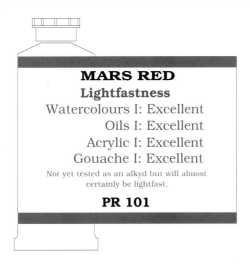

MARS RED
Lightfastness
Watercolours I: Excellent
Oils I: Excellent
Acrylic I: Excellent
Gouache I: Excellent
Not yet tested as an alkyd but will almost
certainly be lightfast.
PR 101

Mars Red is produced by further heating Mars Yellow.

As with the other Mars colours it is an artificial version of the naturally occurring iron oxides.

In hue, Mars Red can be very similar to its natural counterpart, Burnt Sienna, and is used as such by many artists.

Being manufactured rather than mined, the colour is chemically purer and consist-ent between batches.

However, as with other colours in this group, it tends to be a little harsh in colour and less transparent than natural earths.

It is perhaps for these reasons that they have not replaced the latter.

Generally an opaque colour which covers previous work very well. Reasonably transparent versions are also available.

Because it can vary in colour between manufacturers, and because the transparency also varies, it will pay you to try several makes, if possible, before making a purchase.

Absolutely lightfast, it will retain its colour even in very thin washes, or when mixed with a considerable amount of white.

An inexpensive (or it should be), good all round colour.

Recommended

Mixing tips

To darken Mars Red, think of the colour as a neutral or dulled red orange, and mix with a blue.

Ultramarine Blue will darken the colour giving semi-opaque to semi-transparent results. The darks will be very deep, approaching black.

Cerulean Blue will give semi-opaque to opaque mixes of a different character. It is worth experimenting with the various blues.

Technical information: *Common Name* - Mars Red or Red Iron Oxide. *Colour Index Name* - PR 101. *Colour Index Number* 77491. *Chemical Class* - Synthetic Red Iron Oxide. A*STM Lightfast rating* - Watercolour, oils, gouache, acrylic I: Excellent, not yet tested in alkyds. *Transparency* - Semi-transparent to opaque. *Drying* - An average drier as an oil paint.

Ochre

OCHRE

Lightfastness
This is impossible to give as a
variety of pigments are employed.

A variety of colours described as ochre are available, varying from yellow, through dull orange to reds and browns.

Produced from natural earths they are absolutely lightfast. Earths coloured by iron oxide have not faded after millions of years' exposure to all weathers.

The strongly coloured earths to be found, for example, in the Australian outback are as bright below ground level as the material exposed to almost constant harsh sunlight.

The colour of the various ochres depends on a variety of factors, the iron oxide content, modifying agents such as carbon, manganese oxides, silica and organic matter plus the type of clay base carrier.

At one time all ochres were simply described as 'Yellow Ochre'. The descriptions have now generalised into yellow, gold, golden, brown and red.

Yellow Ochre has its own strong identity, the others are all of the same basic family.

Descriptions vary from Gold/Golden Ochre, Brown Ochre Light/Deep to Red Ochre.

Rather than be too concerned about the actual name I suggest that you try as many examples as possible, study the ingredients and select accordingly.

One way to think about the ochres is that they increase the range of natural earth colours - adding to Raw Sienna and Raw Umber etc.

Although a range of suitable coloured earths are available, many manufacturers nowadays either base their ochres on other standard earths or produce imitations.

Of the ochres available, colours described as Gold or Golden Ochre are usually centred on Yellow Ochre.

If based on a dark type of Yellow Ochre it will be a separate colour and worth considering. If it is very similar or identical to standard Yellow Ochre, be careful that you are not purchasing the same colour twice.

Certain 'Gold' or 'Golden' ochres are imitations based on such combinations as Mars Black, Indian Red and Yellow Ochre, or Raw Sienna, Yellow Ochre and other yellows.

These imitations are convenience colours which are usually lightfast but easily mixed. They tend to lack the subtly of naturally occurring ochres.

'Red Ochre' is very often no more than Light Red (calcined Yellow Ochre, page 35) a fine colour in its own right which should, I feel, be sold as Light Red. Be careful not to purchase the same colour twice.

The description, ochre, suggests to many a coloured earth, not a coloured earth which has been roasted. I am not trying to be picky, but if we could remove some of the confusion on colour names we would all be better off.

Transparency varies between the various ochres but most are semi-transparent.

If genuine, and not simple imitations, the ochres can be a valuable addition to any palette. I will not offer mixing suggestions as the colour varies so much.

Recommended

Technical information: *The details will vary depending on the actual ingredients.*

Raw Sienna

RAW SIENNA

Lightfastness
Watercolours I: Excellent
Oils I: Excellent
Acrylics I: Excellent
Gouache I: Excellent
Alkyds I: Excellent

PBr 7

Like the other natural earth colours, Raw Sienna is absolutely lightfast.

The crude Raw Sienna smeared on the cave wall by the first artists will not have changed in colour to this day. Whatever binder was used might have altered, but not the pigment.

Valued for its transparency, Raw Sienna has a place on many a palette in all media.

It generally lies somewhere between Yellow Ochre and Burnt Sienna in colour. I say generally because several rather dark versions are on the market.

Raw Sienna, named after a particularly fine variety once produced at Sienna, Tuscany, has been in use since painting began.

It has long been valued as a glazing colour, giving warm, semi-transparent golden tans when applied thinly. Such glowing tans are particularly appreciated by the watercolourist.

Although it has good covering power, which can be useful, the colour can look rather 'heavy' when thickly applied.

Due to its rather high oil content it does tend to darken with age, it is the binder which darkens, not the pigment.

Although very similar in make up to Yellow Ochre, Raw Sienna is darker due to its higher silica content.

Despite this it has become common practice to sell Yellow Ochre as Raw Sienna. I have been able to find very few cases where the colour was described as an Imitation.

If there were not clear differences between the two colours they would long ago have merged under the one name.

It is worth being aware of this practice, look for the pigment description PBr 7 Raw Sienna rather than PY43 Yellow Ochre. Otherwise you might end up with two almost identical colours.

Select the genuine article with care and you will have a first class colour. I suggest that you try as many samples as you can first.

Recommended

Mixing tips

A close imitation of the colour can be mixed from a good quality Yellow Ochre and a well made Burnt Sienna.

I emphasise the quality aspect because both must be

reasonably transparent, not clogged with dulling filler.

For mixing purposes it can be considered as a neutral or dulled orange - yellow.

With a little experimentation you will find the mixing complementary, a violet with a leaning towards blue.

Technical information: *Common Name* - Raw Sienna. *Colour Index Name* - PBr 7. *Colour Index Number* 77492. *Chemical Class* - Natural Iron Oxide. A*STM Lightfast rating* - Watercolour, oils, acrylics, gouache and alkyds I: Excellent. *Transparency* - Semi-transparent to transparent. *Staining power* - Medium. *Drying* - Medium to fast drier forming a tough, reasonably strong film in oils. Medium to high oil content.

Raw Umber

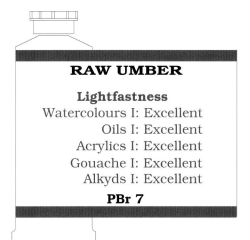

RAW UMBER

Lightfastness
Watercolours I: Excellent
Oils I: Excellent
Acrylics I: Excellent
Gouache I: Excellent
Alkyds I: Excellent

PBr 7

The use of raw Umber in easel painting was not mentioned until the 11th Century. However, it is believed that it was in use from far earlier times.

A natural earth colour, it is mined at various locations, some of the better qualities coming from Cyprus.

There are two schools of thought regarding the origination of the name. Some maintain that it was derived from a production site at Umbria in Italy, others believe that it came from the Latin 'Ombra', meaning shade or shadow.

A rather pleasant cool brown which varies considerably in colour depending on the manganese and aluminium silicate content. It leans variously towards yellow, green and dull grey.

It is usually considered that the better qualities are slightly greenish

The transparency varies although it is generally semi-opaque. Some of the deeper shades are a little more transparent than the lighter.

It covers quite well but is seldom used nowadays at full strength over large areas as it takes on a rather dark appearance.

In oils it tends to dry quite quickly, which can cause problems. When painted over slower drying colours it can crack as the lower, softer paint layers expand and contract under the dried layer of Raw Umber.

This is a consideration with all fast - drying paints.

It has a rather high oil content which leads to a gradual darkening of the colour over time, the oil darkening, not the pigment.

As with all colours which contain a high level of oil, it can absorb oil from subsequent layers if it is painted over whilst still wet.

Although the true pigment makes an excellent paint in all media, and is inexpensive, several manufacturers cannot resist imitating it with mixes. You might well come across 'Raw Umber' which is in fact a mix of Mars Red, Mars Yellow, PG 10 Green Gold and Carbon Black, or Raw Umber to which has been added Burnt Sienna and Mars Yellow.

Why do they do it? I really do not know. Apart, to my mind, from it being deceitful and misleading to describe such concoctions as Raw Umber, the mixes do not improve on the colour they are imitating, in fact they are often inferior even if usually lightfast.

Raw Umber is an absolutely lightfast colour which suits many artists in whatever medium. If it is a colour that you can employ, it will be a sound purchase.

Recommended

| Mixing tips |

Of limited use in colour mixing as it can darken, but not in a controlled way. I suggest that it is best used without further addition.

Technical information: *Common Name* - Raw Umber. *Colour Index Name* - PBr 7. *Colour Index Number* 77492. *Chemical Class* - Natural Iron Oxide containing Manganese. A*STM Lightfast rating* - Watercolour, oils, acrylics, gouache and alkyds I: Excellent. *Transparency* - Semi-opaque. *Staining power* - slight. *Drying* - Quick drier forming a tough, flexible film in oils. Medium to high oil content.

Sepia

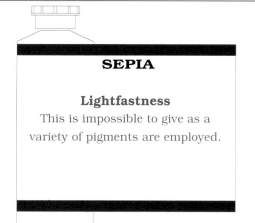

SEPIA

Lightfastness
This is impossible to give as a variety of pigments are employed.

Sepia, a blackish-brown, was originally produced from the dried ink sac of the cuttlefish or squid.

Sepia was originally produced from the dried ink sac of the cuttlefish or squid. It was a semi-transparent blackish brown with fairly good tinting strength. Reasonably lightfast in heavier layers but tended to fade in thin washes.

Nowadays it is no more than any concoction which will give a blackish brown. Mixtures such as Raw Umber and Lamp Black, Yellow Ochre and Carbon Black etc.

Although inexpensive, lightfast black and brown pigments abound, several manufacturers produce a Sepia which deteriorates in light. It's amazing. Help the name to slip into obscurity.

Not Recommended

Technical information: *The details will vary depending on the actual ingredients used.*

Van Dyke Brown

VAN DYKE BROWN

Lightfastness
Has failed all known lightfast testing.
Unsuitable for artistic expression.

NB 8

Genuine Van Dyke Brown is a peat-like substance dug from pits best thought of as ancient compost heaps.

It is completely unsuitable for artistic use in any form.

Named after the artist especially fond of using it. Tends to quickly fade to a cold grey-brown. Knowledgeable artists have avoided it for centuries.

Sometimes imitated by various mixtures which might or might not be lightfast.

Manufacturers offering genuine NB 8 (Natural Brown 8) have much to answer for in the way of ruined paintings.

Not Recommended

Technical information: *Common Name* - Van Dyke Brown. *Colour Index Name* - NB 8 (Natural Brown 8). *Colour Index Number* NA. *Chemical Class* - Organic matter. *ASTM Lightfast rating* - Not tested in any media. *Transparency* - Semi-transparent to transparent. *Staining power* - slight. *Drying* - very slow drier forming a weak, soft film in oils. The oil content is very high.

Venetian Red

VENETIAN RED

Lightfastness
Watercolours I: Excellent
Oils I: Excellent
Acrylics I: Excellent

Alkyds and gouache not tested but will almost
certainly be lightfast.

PR 101

Venetian Red was at one time the name for a naturally occurring earth colour. It is now widely used for a synthetic iron oxide red biased towards orange.

There is a wide range of colours available under the Colour Index Name, Pigment Red 101.

The synthetic iron oxides are differentiated from each other by colour alone, as they are all of the same basic make up.

When making a selection from this range, do bear in mind that the colour description will vary between manufacturers.

One company's Venetian Red might be almost identical to another's Indian Red, which in turn could be almost the same colour as a third's Mars Red, and so on.

There can be a lot of confusion over these various dulled orange reds, hopefully I will have helped in some way to clarify the situation.

Occasionally an inferior red is added, but as you will always check the ingredients, you will be able to quickly spot this and avoid the colour.

If the pigment is given as PR 101 (without any additives), you can be confident in choosing the colour type.

Try as many versions as possible before deciding on a colour which will suit your work. All PR 101s will be equally lightfast, all should handle well in any media, be fairly strong, cover well (semi-opaque), and also be inexpensive.

Recommended

Mixing tips

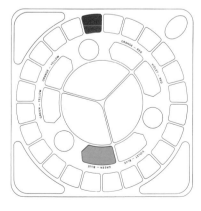

Being a neutralised (or dulled), red-orange, the mixing partner will be one or other of the green-blues.

It will darken and become a little more transparent with Phthalocyanine Blue.

Or darken and retain its opacity with Cerulean Blue.

Technical information: *Common Name* - Venetian Red. *Colour Index Name* - PR 101. *Colour Index Number* 77491. *Chemical Class* - Synthetic Iron Oxide (yellowish hue). A*STM Lightfast rating* - Watercolours, oils and acrylic, I: Excellent, not yet tested in alkyds or gouache. *Transparency* - Semi-opaque. *Drying* An average drier forming a strong film in oils. Some versions can form a brittle film. Low to medium oil content.

Miscellaneous browns

Bitume

Bitume, a title from the past, originally referred to an oil paint produced from bitumen or tar, it never actually dried and even on paintings which have survived it can still alter with changing temperatures.

The paint tended to move about, causing cracks in other layers, and all but destroyed any painting on which it was employed.

Brown Pink

There are several 'Brown Pinks' on the market in various media. Pink was at one time the noun for yellow. For 'Brown Pink' read 'Brown Yellow', a fairly accurate description in many cases.

A variety of ingredients are used to produce the various versions on the market, few give a colour which will not fade or deteriorate in one way or the other. One Brown Pink that I tested changed first to a light reddish-brown as the yellow content faded, then moved to a light grey as the Alizarin Crimson element left the scene.

Caput Mortuum

Another name from the past is Caput Mortuum, a Latin name used at one time for a dull violet-brown which was manufactured from an industrial by-product.

Nowadays the colour is usually a synthetic iron oxide such as Mars Violet or Indian Red, colours also available under their own names.

Pozzuoli Earth

The name of an iron oxide, of volcanic origin which was at one time produced at Pozzuoli, near Naples, has also been handed down. As with Caput Mortuum it now refers to either Mars Red or Indian Red. Sometimes natural earths are added.

Transparent Brown

There are various Transparent Browns, Transparent Oxide Browns, Yellows and Reds on the market. They are either standard browns or simple mixes of standard colours. Look out for the addition of unreliable yellows and reds to such colours.

Dragon's Blood

Dragon's Blood is a title from way back. A dull reddish-brown at one time produced from resin. It was originally said to have come from the mingled blood of an elephant and a dragon as they fought to the death. Where used nowadays the name too often refers to a mix containing fugitive pigments. A pity, as it is my favourite colour name.

As we have an excellent range of brown pigments from which to choose, I suggest that few of the colours which could be described as miscellaneous are of any real value. As with other colour groups, certain browns on offer are renamed standard colours, whilst others are simple mixes.

Some of the mixes are reliable, others will deteriorate quickly. Many of the fancy names from the past were at one time used for browns which were considered to be inferior.

Brown pigments to choose or avoid

The following pigments have not all been subjected to ASTM testing. Where they have not, I am offering guidance based on other independent testing as well as my own.

Reliable pigments - all have been subjected to vigorous testing.

PBr 6 Mars Brown, with option of adding the name Brown Iron Oxide - ASTM rated I: Excellent, as an acrylic and as an oil paint. Also rated I: Excellent as a watercolour during own testing.

PBr 7 Burnt Sienna - tested ASTM I: Excellent in all media.

PBr 7 Burnt Umber - tested ASTM I: Excellent in all media.

PBr 7 Raw Sienna - tested ASTM I: Excellent in all media.

PBr 7 Raw Umber - tested ASTM I: Excellent in all media.

PBr 11 Manganese Ferrite - tested ASTM I: Excellent as a gouache. Not tested in other media.

PBr 25 Benzimidazolone - tested ASTM I: Excellent in gouache.

Possibly suitable in certain media but might tend to fade as a watercolour.

PBr 24 Chrome Titanate Yellow - tested ASTM I: Excellent in gouache. However, failed our own testing as a watercolour. Use with caution in this media.

Most unsuitable for artistic use - poor to very poor lightfastness.

Certain of the following might prove reliable in oils, acrylics or alkyd but all have failed convincingly in other areas. Why take the chance of using them?

Natural Brown 8 Van Dyke Brown - tested IV: Will fade rapidly following our own testing. Also has a very poor reputation.

PBr 8 Manganese Brown - tested IV: Will fade rapidly following our own testing. Also has a very poor reputation.

Please note: the Colour Index Number 77491 can be used instead of 77492 for PBr 7.

Introduction to greys

Greys which have been pre-mixed by the colormen, are, to my way of thinking, entirely superfluous.

At first sight they might appear to be useful, convenience colours. But their restricted range and common overuse quickly stamps an influence over a painting.

An influence which many find to be very limiting. It is not difficult to spot a painting centred on Payne's Grey for example, as the black content will sully any colour with which it is mixed.

A 'Payne's Grey' produced on the palette will be of far greater value in all respects.

It does not require a great deal of skill on the part of a painter to produce a vast range of coloured greys by mixing complementaries.

Such greys are not only easy to produce, but they will lend themselves towards harmonising colour arrangements.

By using only reliable pigments, they will also be lightfast. This is not the case with many pre-mixed greys.

Miscellaneous greys

You will find a variety of greys on the market which do not fall under the standard description given on the following pages. This is particularly the case where gouache is concerned and some very imaginative descriptions are in use.

In the main, such greys are either just black under another name or a mixture of black and white.

Other combinations are available which contain traces of various reds and yellows. If considering a purchase, do check such ingredients carefully as there are greys on the market which will be affected by light.

But why even consider a purchase? A vast range of greys can be mixed with ease from the complementaries.

A well chosen blue and an orange, a red and a green or a yellow and a violet, if paired well, will provide an almost never ending series of subtle and reproducible greys of all descriptions.

The only reason that such a vast range of colours, including greys, is on the market is because artists have always struggled to mix their colours. This need no longer be the case.

Charcoal Grey

PBk8 Charcoal Black is sometimes used to produce this colour. It is lightfast but often a little gritty. If you need such grittiness (and we are all different), you should be aware that the smooth Lamp Black is also sold as Charcoal Grey, as is a mix of Ivory Black and Carbon Black.

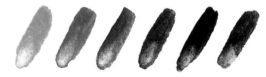

Grey of Grey - This Grey - That Grey etc.

When purchasing a prepared grey it will pay to check the pigments used very carefully. Consider not only the reds and yellows which might be introduced but also the black in question. I suggest that you avoid any grey containing PBk 1 Aniline Black, as it can fade.

Davy's Grey

DAVY'S GREY

Lightfastness
This is impossible to give as a variety of pigments are employed.

This dull, yellowish grey was at one time mainly based on powdered slate.

As such it was often very gritty and did not brush out too well.

The name has been retained for almost any mixture of pigments which will give a colour varying between yellow grey to a very dark blackish green.

All manner of ingredients are used, various greens, browns, blacks, yellows and whites. The only limitation, it would seem, is the imagination of the manufacturer.

Because of the diversity of the mixes, you take pot luck if you purchase without first checking the ingredients.

If these are not clearly given on the label do not even consider a purchase. If you do not have immediate access to such information then the manufacturer either has something to hide or is less than understanding of the requirements of the concerned artist.

It is not good enough to only publish information in a separate brochure, which might or might not be available. Normally the latter case.

Some versions of this colour are absolutely lightfast, others are disastrous.

All versions of this colour are easily duplicated on the palette.

If one manufacturer has mixed Phthalo Blue, Yellow Ochre and Ivory Black, you can do the same after reading the list of ingredients.

Better still, mix such coloured greys yourself using reliable colorants. They need not then contain the black which is present in virtually all examples of this colour.

If you have decided not to use black in your work because you feel that it sullies other colours, why introduce it this way?

Not Recommended

Mixing tips

As the colour varies a great deal, it is not possible to give advice on how to match it exactly though mixing.

Come to think of it, why would you want to? Surely it is just one coloured grey amongst the thousands which are available to the painter with a basic understanding of colour mixing. An understanding now easily acquired.

The colour varies a great deal between manufacturers.

Similar dull yellow- greys can be produced by adding a touch of red-violet to a complementary green-yellow such as Hansa Yellow Light or Cadmium Yellow Lemon.

Technical information: *The details will vary depending on the actual ingredients used.*

Neutral Tint

NEUTRAL TINT

Lightfastness
This is impossible to give as a variety of pigments are employed.

Neutral Tint is just one more name to add to a list of colours in order to increase a manufacturer's market share.

It has absolutely nothing to do with a standard colour or the use of a traditional mix.

The name does not fit any particular colour type as it varies from a dark blackish blue to dull greyed violet through to black.

It also does not fit any particular collection of pigments as a wide range of almost anything is mixed to produce the various versions on the market.

Around 50% of the 'Neutral Tints' on the market are entirely unsuitable for artistic expression as they contain pigments which will deteriorate under light.

Rather than complicate life for themselves, several manufacturers simply tube up Mars Black, or a mix of Ivory Black and Carbon Black and label it Neutral Tint.

A tube of black from the same company will be virtually identical.

The majority of examples on the market, in whatever media, contain black.

As with Davy's Grey, if you wish to exclude black from your palette, do not allow it in by the back door.

Certain colours, such as Naples Yellow (the modern imitation), can be considered as convenience colours, substances sold as Davy's Grey or Neutral Tint do not, in my opinion, deserve to come under this description.

Nearly all blended greys contain black, which will always destroy the nature of any colour with which they are mixed.

More importantly the use of such pre-mixed greys leads first to limitations in colour mixing and understanding and then onto limited work.

It is all too easy to drop in a touch of grey to darken a colour. But it is a method of working which will limit possible results, destroy the character of the colour to which it has been added and, if overdone, stamp its identity on a painting.

Do not join those who rely on others to mix a very limited and often damaging range of greys for them.

Not Recommended

Mixing tips

A clear understanding of the way in which mixing complementaries behave will give you a vast range of coloured greys which can be harmonised with ease.

Perhaps my book 'Blue and Yellow Don't Make Green' will help in this regard.

Greys, produced from reliable contributing colours can be blended with ease by the artist able to control colour mixing.

Technical information: The details will vary depending on the actual ingredients used.

Payne's Grey

PAYNE'S GREY

Lightfastness
This is impossible to give as a variety of pigments are employed.

I meet many artists who tell me that they would not use black in their work because of its dulling effect on other colours.

It later transpires that through the use of what has become a fairly standard convenience colour, Payne's Grey, they had been using black all along.

Payne's Grey is basically a mix of a blue and black, with or without additions.

In general it is either Ultramarine and black or Phthalocyanine Blue and black.

Occasionally the blue is either Prussian Blue or PB60 Indanthrone Blue

The black tends to be either Ivory Black or Carbon Black, although this factor will make little difference to the final colour.

In many examples, the black content is so high that any blueness is only evident in very thin washes.

Various other colours are commonly added to the base black and blue. These are usually the unreliable Alizarin Crimson (which gets everywhere), various violets and Quinacridone Red.

Such mixes are generally lightfast but around 10% contain ingredients which will fade.

In practice this will make very little difference as it is usually the slight red content which is affected.

Many artists find it convenient to purchase this colour ready mixed, perhaps it is because they do not realise how easy it is to prepare.

If your favourite make is a mix of say Ultramarine and Ivory Black, a few moments stirring and you will have it on your palette.

By far the better approach, however, will be to mix such dark blues using colours which will not dull and distort others during mixing.

Not Recommended

Mixing tips

The close complementary pair Burnt Sienna and Ultramarine Blue will give a range of such darkened blues.

Alternatively you could use Phthalocyanine Blue.

The transparency of such mixes adds extra value as they will also cover well due to the depth of colour.

Technical information: The details will vary depending on the actual ingredients used.

Introduction to blacks

The first pigment ever used was probably soot from the fire. Either used directly or mixed with animal fat (or some other sticky substance), it was rubbed onto the rock surface of an overhang or cave.

The same basic material has been in use ever since. Carbon, produced from the burning of a wide variety of substances, has provided most of the black pigments throughout the ages.

Various oils, tars, woods, ivory and animal bones have been used to give pigments which varied from rich and velvety to dull and greasy.

Although many vegetable-based blacks were rather brownish and difficult to work, a fine black could be obtained from charred fruit stones, particularly peach stones.

There are various thoughts on the use of black in painting. Many, including myself, feel that it destroys the nature of other colours with which it is mixed and when used unmixed, gives the appearance of damage to the painting surface.

A rich, velvety dark, without the harshness of black pigment can easily be mixed from Ultramarine Blue and Burnt Sienna.

Black pigments to choose or avoid

The following pigments have not all been subjected to ASTM testing. Where they have not, I am offering guidance based on other independent testing as well as my own.

Reliable pigments - all have been subjected to vigorous testing.

PBk 6 Lamp Black - tested ASTM I: Excellent, in all media.

PBk 7 Carbon Black - tested ASTM I: Excellent, in watercolour, oils, acrylic and gouache.

PBk 8 Charcoal Black - not yet tested under ASTM conditions but rated I: Excellent in our own testing and has an excellent reputation.

PBk 9 Ivory Black - tested ASTM I: Excellent, in all media.

PBk 10 Graphite Gray - tested ASTM I: Excellent, as an acrylic.

PBk 11 Mars Black - tested ASTM I: Excellent, as an acrylic and oil paint.

PBk 19 Gray Hydrated Aluminum Silicate - tested ASTM I: Excellent, as a watercolour. More of a dark grey than a black. Often found in cheaper paints.

Most unsuitable for artistic use - poor to very poor lightfastness.

PBk 1 Aniline Black - not tested under ASTM conditions. Failed our own testing and has a very poor reputation. In use despite the variety of inexpensive and lightfast black pigments available.

Ivory Black

IVORY BLACK

Lightfastness

Watercolours I: Excellent

Oils I: Excellent

Acrylics I: Excellent

Gouache I: Excellent

Alkyds I: Excellent

PBk 9

Genuine Ivory black was often produced using the off-cuts and scrapings from the comb making industry.

Genuine Ivory Black was originally produced by packing ivory scraps into sealed iron pots.

These were then subjected to heat until the ivory was thoroughly charred. The resultant black material was then ground into a pigment.

It gave a rich velvety black which was in much demand and sold for a good price.

The pigment was lightfast, and unaffected by acids and alkalis.

The ivory was commonly obtained from comb makers. Well before the time of plastic, many combs were produced from ivory and the resulting scraps and scrapings gave added income to the comb maker.

All was well until the supply of affordable ivory dried up.

Meanwhile, let us turn our attention to Bone Black.

This was an inferior black produced by charring animal bones in sealed iron containers. The bones were first boiled to remove most of the gristle and fat.

Much of the product was rather greasy and had a distinct leaning towards brown.

This cheap and very inferior substance was sold alongside Ivory Black to the less discerning.

When ivory was no longer available at an economic price it was dilemma time for the colour manufacturers.

What to do? Ivory Black was in strong demand and had sold for a very good price. Bone Black was plentiful and very cheap.

Demonstrating a versatility which has not deserted the majority, they simply changed the name of Bone Black to Ivory Black and carried on.

Modern Ivory Black is still produced from charred animal bones. So don't lick your brushes if you are a vegetarian watercolourist.

It is now of a far better quality than in the past as virtually all the fat is removed during manufacture.

Normally possessing a warm brown undercolour, the trend over recent years has been to produce a darker, more neutral black.

Carbon Black is often added for this purpose.

It covers well and many versions will give a reasonably clear thin layer.

Good tinting strength and absolutely lightfast. You should be aware of the high binder content when made into an oil paint.

I will reserve my comments on the use of black in colour mixing to the end of this section as the various blacks have much the same impact. Recommended if you have need for a black paint.

Recommended

Technical information: *Common Name* - Ivory Black. *Colour Index Name* - PBk 9. *Colour Index Number* 77267. *Chemical Class* - Amorphous Carbon produced by charring animal bones. A*STM Lightfast rating* - Watercolours, oils, alkyds, gouache and acrylic, I: Excellent. *Transparency* - Semi-opaque to opaque. *Drying* - A very slow drier forming a soft film in oils. High oil content.

Lamp Black

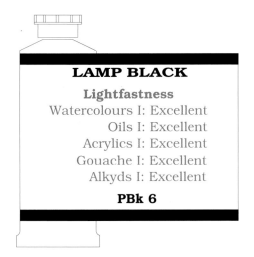

LAMP BLACK

Lightfastness

Watercolours I: Excellent

Oils I: Excellent

Acrylics I: Excellent

Gouache I: Excellent

Alkyds I: Excellent

PBk 6

Lamp Black is basically soot, produced by burning mineral oils, pitch or tar in brick chambers. After collection the soot is heated to remove any oily residues.

Soot produced by various means has been employed as a pigment from the earliest times.

In fact it was probably the first colorant to be used by the cave painter, who would have mixed it with animal fat, or some other sticky substance, and smeared it onto the rock surface.

The Chinese in particular made great use of this black over several thousand years. The soot produced by burning Tung oil nuts or resinous wood was mixed with a gum and beaten extensively. The more it was beaten, the better the product.

It came into wide use in Europe also. Lamp and charcoal black were employed extensively by Medieval artists. Writing in Florence during the 15th Century, Cennino Cennini gave the following method of preparation.

'Take a lamp full of linseed oil and light the lamp. Then put it, so lighted, underneath a good clean baking dish, and have the flame of the lamp come about to the bottom of the dish, two or three fingers away, and the smoke which comes out of the flame will strike on the bottom of the dish, and condense in a mass.

Wait for a while, take the baking dish, and with some implement sweep this colour, that is, this soot, off onto a paper, or into a dish, and it does not have to be worked up or ground, for it is a very fine colour.'

It varies in colour but usually has a bluish undercolour. It will cover well, being opaque, but its very fine particles allow for quite transparent thin layers.

Very strong in tinting strength it will quickly influence other colours.

Being a very light pigment it tends to float to the edge in very wet watercolour washes.

Umber, Viridian or Cobalt Blue can be added to speed up the drying rate in oils, which is very slow. Due to its high oil absorption, a fine over all crackle can develop if it is applied thickly.

An excellent, lightfast black for fine line work.

Recommended

The Chinese produced vast amounts of soot, by various means, for the production of black ink and paints.

Whereas the binder or painting surface might have deteriorated with the passage of time, the actual colorant will have remained a dense black over the centuries.

Technical information: *Common Name* - Lamp Black. *Colour Index Name* - PBk 6. *Colour Index Number* 77266. *Chemical Class* - Nearly pure Amorphous Carbon. *ASTM Lightfast rating* - Watercolours, oils, alkyds , gouache and acrylic, I: Excellent. *Transparency* - Opaque. *Staining power* - None staining. *Drying* - A very slow drier forming a soft film in oils. Very high oil content.

Mars Black

MARS BLACK

Lightfastness
Watercolours I: Excellent
Oils I: Excellent
Acrylics I: Excellent

Alkyds and gouache not tested but
will almost certainly be lightfast.

PBk 11

This dense, absolutely lightfast black has been in use since the early 1900s

A strong tinter, it should be used with care as it will quickly dominate most colours with which it is mixed. Very opaque, it will cover previous work very efficiently if required to do so.

It is also of value in producing clean, opaque brushed line work.

As with other blacks, (apart from PBk 1 Aniline Black), it is absolutely lightfast and has passed all tests to which it has been subjected.

A synthetic iron oxide (another in the family of Mars colours), it is also known as Iron Oxide Black.

The colour varies somewhat from a very deep bluish grey to a brownish black to a deep dense black.

When made into a watercolour it tends to settle into pockets in the paper if applied as a very wet wash.

It is seldom found as a watercolour however, although it is perfectly suitable for all types of paint.

Nowadays it is most commonly made up into an acrylic.

The quality varies somewhat between manufacturers but a simple test will show if any particular version will give a clean, dense black line and cover well. The better grades are good value for money.

Recommended

Mixing tips
(all blacks)

Black has traditionally been used to darken other colours. It will certainly do this but at some considerable cost.

The colour being darkened will always become a lot duller as well as darker and it will also change in character. This change is particularly noticeable with yellows and yellow-greens, which move towards dark 'olive' green.

The colour pairs above have been darkened both by black (colour on the left) and by the complementary mixing partner (on the right).

A carefully chosen mixing partner is far superior to any black as far as keeping colours 'clean' and in character is concerned.

Technical information: *Common Name* - Mars Black with option of adding the name 'Black Iron Oxide'. *Colour Index Name* - PBk 11. *Colour Index Number* 77499. *Chemical Class* - Synthetic Black Iron Oxide. A*STM Lightfast rating* - Watercolours, oils, and acrylic, I: Excellent. Not tested in alkyds or gouache. Transparency - Opaque. *Drying* - An average to slow drier forming a soft but fairly strong film in oils. Very high oil content.

Introduction to whites

An early receipt for a white pigment called for *the chicken bones to be found under the table to be subjected to heat and then ground.*

I doubt that we would find a pile of suitable bones under many modern tables. Although who really knows?

The calcined chicken remains made an inferior white which brushed out poorly.

Oyster shells, similarly burnt and powdered gave a very important white to the Japanese and Chinese. It remained a standard for hundreds of years.

Chalk gave another important but inferior white.

Flake White or Lead White was one of the earliest manufactured pigments. It was then, and still is, the finest of all pigments, giving very tough flexible films as an oil paint.

Zinc White was suggested in the mid 1700s as a possible alternative to Flake White. Although of value in certain areas, it remains inferior to Flake White.

To these two must be added the excellent Titanium White, a valuable all round pigment.

We are well provided for in this area but should become familiar with the various properties on offer, if we are to obtain the results that we desire.

White pigments to choose or avoid

The following pigments have not all been subjected to ASTM testing. Where they have not, I am offering guidance based on other independent testing as well as my own.

Reliable pigments - all have been subjected to vigorous testing.

PW 1 Flake White - tested ASTM I: Excellent as an oil paint and an alkyd. Not suitable for watercolours (although used in at least one make until recently), or gouache.

PW 4 Zinc White - tested ASTM I: Excellent as a watercolour (Chinese White), oil paint, acrylic and gouache.

PW 5 Lithopone - tested ASTM I: Excellent as a gouache. Used more as a filler than a paint pigment.

PW 6 Titanium White - tested ASTM I: Excellent in all media.

PW 7 Zinc Sulphide - tested ASTM I: Excellent as a gouache and in our own testing as a watercolour.

PW 18 Chalk - used more as a filler than a paint pigment.

PW 22 Baryte - used more as a filler or a base for certain 'lake' colours, than as a pigment.

PW 27 Silica - used more as a filler or a base for certain 'lake' colours, than as a pigment.

Chinese White

CHINESE WHITE

Lightfastness
Watercolours I: Excellent
Not applicable to other media.

PW 4

Chinese White is a specially produced, very dense type of Zinc White used exclusively in watercolour paints.

Vapour given off from molten metallic zinc, burnt in a draft of air, is collected in chambers and compressed into powder whilst still hot. (Do not try this at home.)

When this very dense pigment is made into a paint it has far greater covering power than the basic Zinc White used in oil paints.

A very cold pure white, which will bring its coolness to mixes, it has become the standard white of the watercolourist, although to my mind, Titanium White does an equally good job.

Like Titanium White, Chinese White has good covering power, which is often useful for hiding slight mistakes.

In almost every case only the genuine pigment is used, although it is possible to find at least one manufacturer marketing Titanium White

under this name. Why? Who could ever know.

When well produced, as it generally is, it handles very well, giving smooth applications. Poorer qualities, which do not cover well, might well be produced using standard Zinc White.

Rather strong, it will reduce other colours with ease during mixing. A cold, pure, absolutely lightfast white which is pleasant to use when well produced.

Recommended

Mixing tips

Chinese White is the principal white of the watercolourist, yet, in theory, when working in watercolours the white of the paper is supposed to provide the tints.

Many purists would state this to be the case, but in practice the range of available colours is reduced if white is always avoided.

As previously mentioned, white will always dull and cool a colour, changing its character. It is important to realise

*As a thin wash
(background white).*

Reduced with white paint.

*As a thin wash
(background white).*

Reduced with white paint.

that such colours cannot be produced any other way. The dulled pink shown above, for example, could not be produced by the white of the paper alone, neither could the

dulled blue tint. There can be no such thing as an 'incorrect' colour and your range of effects could be slightly limited without the occasional selective use of white.

Technical information: *Common Name* - Chinese White. *Colour Index Name* - PW 4. *Colour Index Number* 77949.
Chemical Class - Zinc Oxide. *ASTM Lightfast rating* - Watercolours I: Excellent, Transparency - Opaque.

Flake White

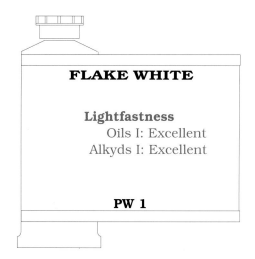

FLAKE WHITE

Lightfastness
Oils I: Excellent
Alkyds I: Excellent

PW 1

The preparation of white lead at one time involved a great deal of handling, which caused many instances of lead poisoning. So dangerous was it, that at least one English company would only allow women to be involved in the stacking of the lead blocks. Fortunately an attitude not liable to find favour nowadays. So much for the 'good old days'!

This is one of the earliest manufactured pigments on record. The early Egyptians imported lead ingots from Spain for its manufacture as early as 1500 BC and the Chinese have used it for several thousand years.

Without any doubt at all, Flake, or Lead White has proven to be the finest pigment of all time. It is very opaque, quick drying and has a smooth buttery consistency when well made. Its greatest asset however, is that it dries to a very tough, flexible film.

Many earlier paintings are testimony to the flexibility of this colour. If you come across an old portrait painting which has deteriorated badly, apart from the face and possibly the hands (which have remained in almost perfect condition), you can be fairly certain that this was the white used to lighten the flesh tones.

Only suitable for use as an oil paint or alkyd. Without the protection of the binder it would quickly darken on exposure to the atmosphere. This factor makes it unsuitable for use in watercolours. However, I have found one example of its use in this media. As such it was prone to darkening and also dangerous - as many watercolourists point their brushes by mouth (a risky practice in its own right).

Do not be deterred by the toxicity of Flake White. Without a doubt it is toxic and even small amounts taken into the body on a regular basis can lead to lead poisoning.

But there is absolutely no reason to take it into the body. If you do not eat or smoke whilst using it or allow it to remain on the skin, or enter via cuts or other breaks in the skin and take all sensible precautions, it will be perfectly safe to use.

I often use the car battery as a comparison. The acid that it contains can be deadly when drunk, but we live side by side with our car batteries. We also use potentially harmful substances such as bleach in the house. Certain other colours can also lead to health problems if abused. The Cadmium colours for example can build up in the body, but there is no reason for them to lodge there. Over-anxiety in this area could lead to the eventual banning of Flake White, the Cadmiums and a few other colours. At the moment we do not have suitable pigments to replace them.

PW1 is also sold under such names as Lead White, Flemish White, London White and Cremnitz White.

Be wary of examples which have been mixed with Zinc White as they are sometimes sold simply as Flake White. They will not have the flexibility of the genuine article.

This is a superb white pigment which is well worth any extra cost. In mixing, its warm tone will be imparted to other colours.

A tint in which it has been employed will be considerably warmer than a similar tint produced using either Titanium or Zinc White.

Recommended

Technical information: *Common Name* - Flake White. *Colour Index Name* - PW 1. *Colour Index Number* 77597. *Chemical Class* - Basic Lead Carbonate. *ASTM Lightfast rating* - Oils and alkyds I: Excellent. *Transparency* - Opaque. *Drying* - A quick drier forming a particularly tough, flexible film. Very low oil content.

Titanium White

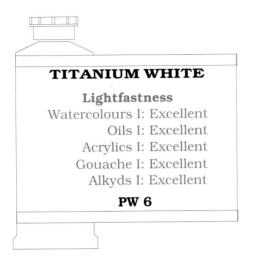

TITANIUM WHITE

Lightfastness
Watercolours I: Excellent
Oils I: Excellent
Acrylics I: Excellent
Gouache I: Excellent
Alkyds I: Excellent

PW 6

In use since the 1920s, Titanium White is a strong, inexpensive, very bright white. It is considered by many to be the purest white of all, although some varieties can be very slightly creamy in colour.

There were problems in the early production stages but these were overcome and this pigment has more than proven its value to artists ever since.

It is absolutely inert, being unaffected by other pigments, light, weak acids or alkalis. It has passed every lightfastness test to which it has been subjected.

Titanium White is the strongest of the whites and a small amount will quickly influence any other colour with which it is mixed.

It is also very opaque and covers well even in fairly thin applications. This can be a great advantage as white is often called upon to cover previous work and at the same time provide a base for further paint layers.

Small amounts of zinc white are often added to the colour during manufacture as an oil paint to prevent the slight yellowing which can otherwise occur.

As a watercolour it is not widely used although it is superb in this media.

In all types of paint it is subject to the manufacturers' love of fancy and trade names.

If they would only call it Titanium White in every instance, rather than names such as 'Opaque White' or amazingly 'Zinc White' in one case, artists would be better served.

An excellent all round white. It has not, as expected by many, replaced Flake or Zinc White, having neither the warmth of the former or the transparency of the latter.

Recommended

Mixing tips

All whites will dull and cool any colour to which they have been added.

This is particularly noticeable with warm colours such as red and orange. If any colour is applied thinly to allow background white to create the tint, it will always remain brighter and warmer than when mixed with white

Shown above is a thin wash of Cadmium Red Pale. The colour remains relatively bright.

When Titanium White is added the tint becomes a lot duller and cooler when compared to the wash on the left.

Technical information: *Common Name* - Titanium White. *Colour Index Name* - PW 6. *Colour Index Number* 77891. *Chemical Class* - Titanium Dioxide. *ASTM Lightfast rating* - Watercolours, oils, alkyds, gouache and acrylic, I: Excellent. *Transparency* - Opaque. *Drying* - A slow drier as an oil paint. Medium to low oil content.

Zinc White

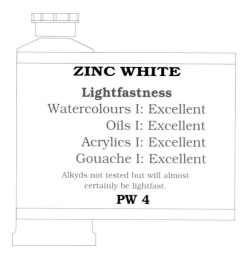

ZINC WHITE

Lightfastness

Watercolours I: Excellent
Oils I: Excellent
Acrylics I: Excellent
Gouache I: Excellent

Alkyds not tested but will almost
certainly be lightfast.

PW 4

Zinc White, as an oil paint, can cause cracking when mixed with other colours.

Zinc White was suggested as a possible replacement for Flake White in 1746.

It did not have the incompatibility problem that Flake White had with certain colours (problems now overcome), and it was not prone to darkening on exposure to the atmosphere.

It was not until the 1830s however, that production on a commercial basis commenced. First as a watercolour and later as an oil paint.

A very cold, pure white which will quickly lighten other colours, being reasonably strong.

It varies from being semi-transparent to semi-opaque. Its transparency in fact is possibly its main attraction.

It will bring its coldness to any colour with which it is mixed. As has been mentioned elsewhere, the addition of white will always cool and dull a colour.

Zinc White, being very cool, will have an even greater effect in this area than other whites.

As outlined on the previous page, a concentrated version of this pigment is produced for watercolourists under the name Chinese White.

Commonly available made up into an oil paint, there are limitations that should be taken into account.

As an oil paint it dries to a hard and very brittle film, prone to cracking. Especially when applied at all heavily.

Unless you really need the transparency of this white I would suggest that you avoid it as an oil paint.

If reasonably large amounts are added to other colours, they too can crack or craze very readily.

It takes its time over drying and will slow the drying rate of any mix in which it has been used.

It is quite commonly used as a low cost ground, which can be disastrous due to its tendency to crack. Such cracking often affects the entire painting.

Suitable for other media but is most commonly available as an oil paint.

Occasionally sold under names such as Permanent White, or mixed with other whites and sold as Mixed White.

Not Recommended as an oil paint

unless its transparency is vital to your work

Technical information: *Common Name* - Zinc White. *Colour Index Name* - PW 4. *Colour Index Number* 77949. *Chemical Class* - Zinc Oxide. *ASTM Lightfast rating* - Watercolours, oils, gouache and acrylic, I: Excellent, not yet tested as an alkyd. *Transparency* - Opaque. *Drying* - Very slow drier forming a particularly hard, brittle film. Low oil content.

The various media

Watercolours

The gum used in watercolours will hold the particles together efficiently but does not form an all-enveloping film, as is the case with oil paints or heavily applied acrylics.

Therefore, when the paint is thinned with water and applied, the surface is not level but presents a matt finish.

Various additives (usually based on gum) are on the market which will change the appearance from a matt surface to a more glossy effect. Such additives usually cause more harm than good as they can lead to cracking of the paint film. If you wish for a gloss effect, it will be better to work in oils or acrylics.

Gouache

You should be aware that Designer's Gouache, as the name suggests, is prepared with designers in mind. They often utilise the smooth opaque finish available to prepare artwork for printing.

As their work is usually for temporary use only, or is stored in darkness, they are seldom concerned with lightfastness. They also often seek particularly bright colours for their work. Such very bright hues tend to be short-lived.

For these reasons, many gouache colours on the market tend to fade or darken rapidly, a point worth bearing in mind as many artists now use gouache.

Oil paints

Oil paints do not dry by evaporation as watercolours do, instead, they dry by absorbing oxygen from the air, at the same time giving off various gasses.

Very complex chemical changes take place within the oil film as it gradually becomes an entirely different product. It becomes a new substance differing both physically and chemically and cannot be changed back to its original state.

Once the drying procedure has started the oil first becomes tacky, then it gells and finally becomes hard.

If the entire procedure takes place after the paint has been applied to the painting surface, it will adhere quite strongly. However, if the drying process is disturbed in any way the adhesive qualities are diminished.

What is often overlooked by painters is the fact that the oil paint left on a palette for several days or even just overnight, has started to change chemically. It has absorbed oxygen and started to change in structure.

If the paint has started to become tacky, or a skin has formed, the common approach is to add a little turpentine to make the paint workable.

But it will already be too late. The drying process, which started some time before, has been interrupted. The thinned paint might be workable but there is a danger of later damage to the painting because the paint will not adhere to the surface as well as it might.

Unless the paint is as fresh as when it came from the tube, and certain slow drying paints will often be, it should be discarded.

Acrylics

Different brands of watercolours, gouache, and oil paints can be mixed together quite safely as their basic make up is relatively simple.

Acrylics, on the other hand can be very complex blends. In addition to the pigment, binder and filler found in other media, acrylics might contain an emulsifier, a thickener, an anticoagulant and antifreeze etc. Most of the additives are to ensure a long shelf life.

It is inevitable that the formulations will vary between manufacturers, not only in the range of ingredients but also in the proportions. Such variations can lead to incompatibilities between the brands which can result in later deterioration of the paint layers, with possible flaking and loss of adhesion. For this reason, it is inadvisable to mix various brands of acrylic paints. It will be better to find a manufacturer who will fulfil your requirements and stay with the same product range.

Summary

Many modern painters still cling to the belief that the excellence of the work of the earlier masters was due in part to the materials at their disposal. As I have indicted, this belief is largely unfounded.

A by-product of the widely held view that earlier methods and materials must have been superior is that many romantic but nonsensical colour names from the past have been retained. We now have a situation where many recent and superb additions to the colour range are marketed under quite meaningless names.

Descriptions such as Caput Mortuum, Stil de grain, and Tyrian Rose still abound and are used to sell all manner of colorants. It all adds to the general confusion and prevents artists becoming familiar with many of the quite superior products on the market.

The descriptions, in many cases, relate to pigments which were either discarded by earlier artists or tolerated by them as they had little alternative.

Guided by 'tradition' and hype - and there is plenty of that around - many will unknowingly select a worthless colour against its superior alternative, which might also be disguised by a fancy or trade name.

Unwarranted and often undeserved loyalty to a particular brand also plays a part in the overall situation.

With extensive colour ranges in each medium, many brands to choose from, conflicting advice and a plethora of colour names, the modern artist is confronted with a bewildering situation.

But the choices must be well made if the materials are to handle well, give the required colour range when mixed and, very importantly not fade or darken when the finished painting is hung.

The range of colour names and pigments on the market is so wide that they could not all be covered in a book such as this. But, if you come across a colour name not mentioned within these pages, you will have the necessary information to decide whether you wish to purchase and use the colour.

If you always check against the pigment lists given after each colour section, you will not go far wrong. I believe that I have covered all of the important pigments which are currently in use in artists' paints.

Hopefully this book will provide the guidance needed for the careful selection of your colours. I wish you well with your painting.

Other titles by the author

Blue and Yellow Don't Make Green

For more than 200 years the world has accepted, without question, that red, yellow and blue - the artists' primaries - give new colours when mixed. And for more than 200 years artists have been struggling to mix colours on this basis.

This book offers a total reassessment of the principles of colour mixing. It is the first major breakaway from the traditional and limited concepts that have caused painters and others who work with colour so many problems.

By unravelling the many ambiguities and myths inherent in the established way of working, the author has transformed colour mixing from a haphazard affair into a thinking process.

ISBN 0 9587891 9 3 ISBN USA 0-89134-622-8

The Wilcox Guide to the Finest Watercolour Paints (UK edition)

The Wilcox Guide to the Best Watercolour Paints (USA edition)

No matter how knowledgeable you are as an artist, you are going to be surprised by some of the facts in this book. It is the first publication to cover the wide range of pigments currently used in artists' watercolours, many of them almost unknown in the art community. The major watercolour manufacturers from around the world are covered.

The artist and the art teacher have been looking at a giant jigsaw puzzle with most of its pieces missing. This book provides those pieces.

ISBN for both editions 0-89134-409-8

Paint Selection Workbook

Paint Selection Workbook

The workbook has been designed to enable full exploration of your chosen paint range.

It is suitable for watercolours, gouache and thinned acrylics. An oils version is planned for the near future.

The characteristics of your own paints can be studied in detail and recorded. Samples can also be taken of the colours used by fellow artists for comparison.

Once complete, the worksheets are placed into protective sleeves. Please contact the School of Colour for further details.

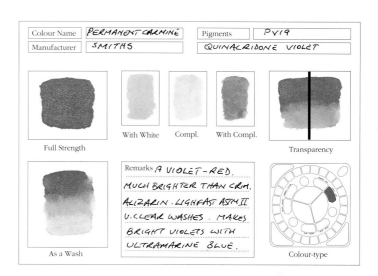

Each of the colours that you are either considering or have decided to include in your range can be explored in depth. At full strength, as a wash, with white added, deciding on the complementary, mixed with the complementary etc. The more that you know about your colours, the better they will serve you.

School of Colour

The School of Colour has been formed to answer an obvious need for information on colour mixing and use.

We have found that colour mixing, colour harmony, colour theory and colour contrast have often been explained in a less than satisfactory way, to the extent that many users of colour find themselves without the information required for a full repertoire.

To help overcome this situation we have developed a series of practical courses, books, colour mixing palettes, workbooks, videos, specially formulated paint ranges and teaching aids. Our products are all based on original research with the needs of the artist at the forefront.

We are keen to work with individual artists and art/craft teachers with a strong interest in colour. Together we can bring about much needed change.

If you would like further information please contact:

The Michael Wilcox School of Color USA
P.O. Box 50760
Irvine, CA 92619-0760
USA
Tel: (714) 461 0672

The Michael Wilcox School of Colour Ltd.
Gibbet Lane
Whitchurch
Bristol BS14 OBX
United Kingdom
Tel: 01275 835500
Fax: 01275 892659

The Michael Wilcox School of Colour
Australia
P.O. Box 516 Wanneroo
Perth 6065
Western Australia

About the author

Michael Wilcox has experienced a varied background, including periods as a professional artist, a conservator of art works and an engineer: which in turn led to a study of light physics in relation to the needs of the artist.

During his research towards a Post Graduate Diploma in Art and Design at Curtin University, Western Australia, he spent equal time within the art and physics departments.

His study led to the book 'Blue and Yellow Don't Make Green'. Published in English, Dutch, Japanese, Korean and Chinese, the book has changed the way that countless artists now mix and use their colours.

This publication was followed by 'The Wilcox Guide to the Finest Watercolour Paints', the book which has led to many of the changes in the pigments used in artists' paints.

Specialist mixing palettes, workbooks and courses were then developed and the School of Colour was formed on an international basis.

With a firm belief that art and science must once again come together, as they did during the Renaissance, the School will continue to develop in this area, with the needs of the artist always coming first.